RUSTIC
MODERN
crochet

18 Designs Inspired by Nature

YUMIKO ALEXANDER

INTERWEAVE
interweave.com

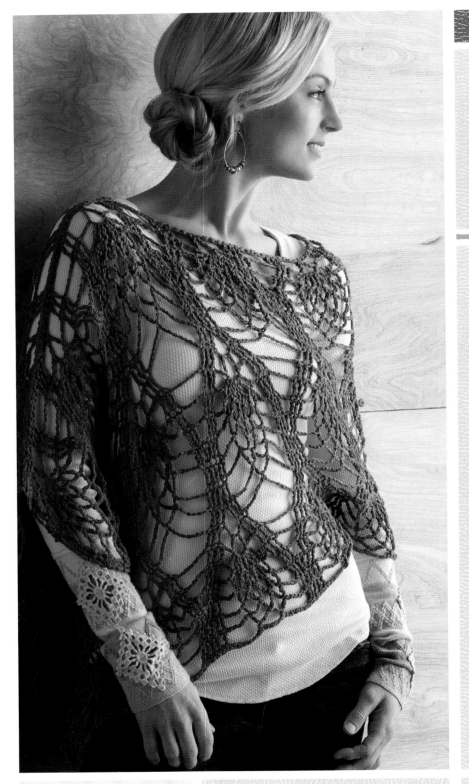

Editor Erica Smith
Technical Editor Karen Manthey
Photographer Joe Hancock
Stylist Emily Smoot
Hair & Makeup Kathy MacKay
Associate Art Director Julia Boyles
Cover and Interior Design Karla Baker
Production Design Katherine Jackson

 Interweave
A division of F+W Media, Inc.
4868 Innovation Drive
Fort Collins, CO 80525
interweave.com

Manufactured in China by
RR Donnelley Shenzhen

Library of Congress Cataloging-in-
Publication Data
Alexander, Yumiko.
Rustic modern crochet : 18 designs inspired
by nature / Yumiko Alexander.
 pages cm
Includes index.
ISBN 978-1-59668-736-3 (pbk.)
ISBN 978-1-62033-040-1 (PDF)
1. Crocheting--Patterns. I. Title.
TT825.A435 2014
746.43'4--dc23

2013021761

10 9 8 7 6 5 4 3 2

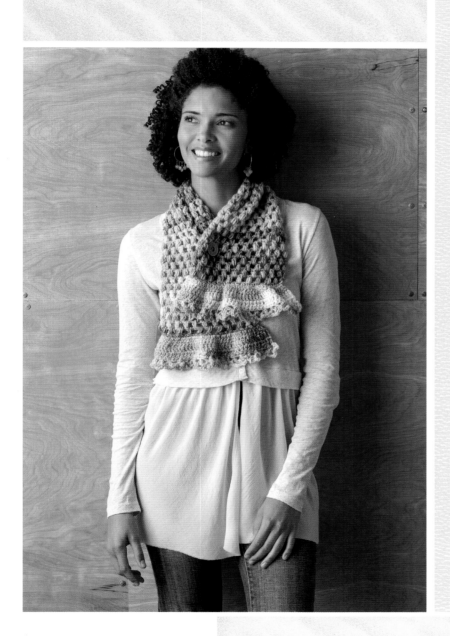

contents

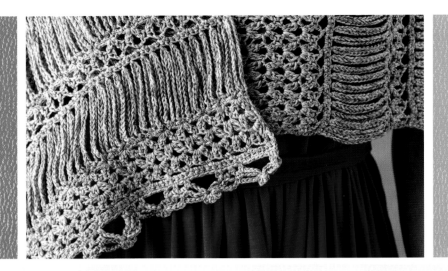

introduction

I love to knit and crochet, and having this book published has been a lifelong dream.

Knitting and crochet have made my life in the United States very beautiful. When I moved here from Japan, my English was limited and everything was new to me. Although the language and culture in the United States and Japan are very different, knitting and crochet have remained a constant in my life. I have enjoyed communicating with people and expressing myself through my design work, and I have met many wonderful friends through knitting and crochet.

Looking back, it is easy to see the path that brought me here. First, my mother is a fiber artist. Because of her, I grew up in a world full of texture and color. My grandparents owned a tailoring business. From them, I learned to pay attention to detail and to appreciate fine handwork.

Around the age of eleven, I spent a lot of time looking at yarns through the window of a shop next to where my mom bought groceries. One day we went in and she purchased a book, yarn, and needles for me. I studied the book, practiced the techniques, and eventually taught myself how to knit.

Once I began making clothes, I needed to figure out how to change the sizes and adapt patterns, because in Japan, the patterns are written for only one size. Soon I was trying new stitches, changing and adapting the patterns to suit me. The next logical step was to design my own patterns, so I did.

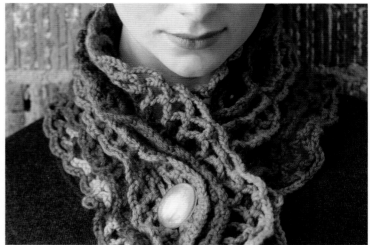

When I was twenty-two, I met a knitwear designer at an exhibition. She helped me improve my skills and taught me more about the design process. That took me in the direction of designing and selling original sweaters for stores in Japan.

In my late twenties, I married an American and moved to the United States. When I started living in Arizona, I did not expect to encounter a large knitting and crochet community due to the warm weather. Eventually, though, I met a knitter who invited me to speak about my knitting and crocheting at a guild meeting. At the meeting, I realized there were others in Arizona who enjoyed making knitted and crocheted items as much as I did. I attended another fiber event and took a class from a local store owner. She told me about her store, Tempe Yarn & Fiber, and explained how several people met there regularly to crochet and knit. Today, I visit the store frequently and enjoy being surrounded by yarn, lots of colors, texture, and good friends who are always willing to try on my designs for style and fit. I bribe them with yummy desserts on "help me name my designs" day.

My design ideas come from what I want to have in my closet. Each design needs to be something I won't find in the usual clothing stores. I love texture as much as I love color. I believe the possible combinations of stitches are endless. I spend long hours with my swatches, trying everything I can think of as I listen to the yarns tell me how they want to be crocheted or knitted. I want to create things I can be proud to wear and use, both functional and fashionable.

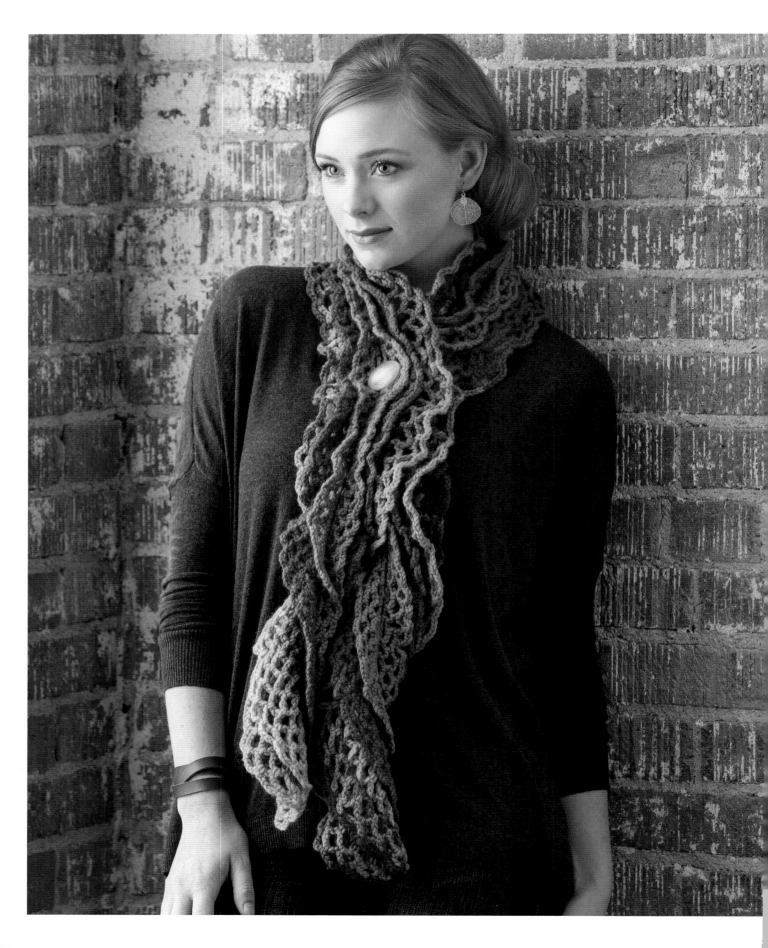

FINISHED SIZE
6" (15 cm) wide and 60"
(152.5 cm) long, unstretched.

MATERIALS

yarn

Worsted weight (#4 Medium).

SHOWN HERE: Universal Yarn
Deluxe Worsted (100% wool;
197 yd/100 g): #12183 City Turf
(A) and #12181 Bronze Brown
(B), 1 skein each.

Universal Yarn Deluxe Worsted
Long Print (100% wool;
197 yd/100 g): #03 Autumn
Equinox (C), 2 skeins.

hook

J/10 (6.0 mm). *Adjust hook size
if necessary to obtain correct
gauge.*

notions

One 1½" (3.8 cm) diameter
button; 41 stitch markers;
darning needle.

GAUGE

Ch 25 and work strip
stitch pattern for 4 rnds.
Swatch should measure 9"
(23 cm) wide and 4" (10 cm)
deep.

LACY *shoals*

While organizing my fabric stash, I found myself creating piles with larger pieces at the bottom and smaller pieces on top. That is how I came up with this design. This three-tier scarf is joined together as you go, so there are no seams to sew at the end. If you want to experiment, try combining different fibers, textures, colors, and weights of yarn to create your own unique version of this fun pattern.

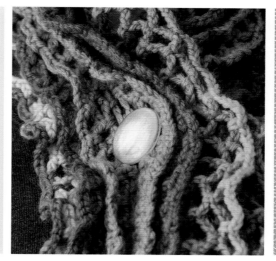

stitch guide

STRIP STITCH PATTERN
(starts with a multiple of 5 ch sts, plus 10 ch sts)

SET-UP RND: Ch 210, sc in the 10th ch from hook, place a marker around sc, *ch 4, sk next 4 ch, sc in next ch, place a marker around sc; rep from * across to last 5 ch, ch 4, sl st into last ch—40 markers.

RND 1: Sc in next ch-5 sp, place a marker in first st of rnd, [ch 4, sc] twice in the same ch-5 sp, ch 4, (sc, ch 4, sc, ch 4) into each ch-4 sp across to end ch-9 sp, (sc, [ch 4, sc] 4 times) in end ch-9 sp, (sc, ch 4, sc, ch 4) into each ch-4 sp across to last ch-4 sp, (sc, ch 4, sc) in end ch-4 sp, ch 1, dc in first sc of rnd instead of last ch-4 sp. Remove marker from first sc.

RNDS 2 AND 3: Sc in first sp, place a marker in first st of rnd, (ch 4, sc) in each ch-4 sp around, ch 1, dc in first sc—86 ch-4 sps. Remove marker from first sc.

RNDS 4 AND 5: Sc in first sp, place a marker in first st of rnd, (ch 5, sc) in each ch-sp around, ch 1, dc in first sc. Remove marker from first sc.

RND 6: Sc in first sp, place a marker in first st of rnd, (ch 5, sc) in each ch-5 sp around, ch 5, join with a sl st in first sc. Remove marker from first sc. Fasten off.

instructions

BASE STRIP

This will be the middle layer of the scarf. With B, work in strip stitch pattern (see Stitch Guide), ending after Rnd 4. To complete a strip ending with Rnd 4, end last rnd with ch 5, sl st in sc at beg of rnd instead of ch 2, dc in first sc.

SMALLER STRIP

With right side of base strip facing up, with A, make and join smaller strip to base strip as foll:

JOINING RND: Ch 5, sc around first marked sc st on the base strip, *ch 4, sc around next marked sc st on the base strip; rep from * across to last marker, (sc, ch 9, sc) around last marked sc, working in opposite direction across base strip, *ch 4, sc around next sc st on the base strip; rep from * across last marker, ch 4, sk next 4 ch, sl st in last ch of beg ch-5.

You still need all markers on the base strip; do not remove them.

Work Rnds 1–3 of strip stitch pattern. To complete a strip ending with Rnd 3, end last rnd with ch 4, sl st in sc at beg of rnd instead of ch 1, dc in first sc.

Note: *Use only Yarn A ch-sps while you are working the strip stitch pattern (do not crochet into Yarn B spaces).*

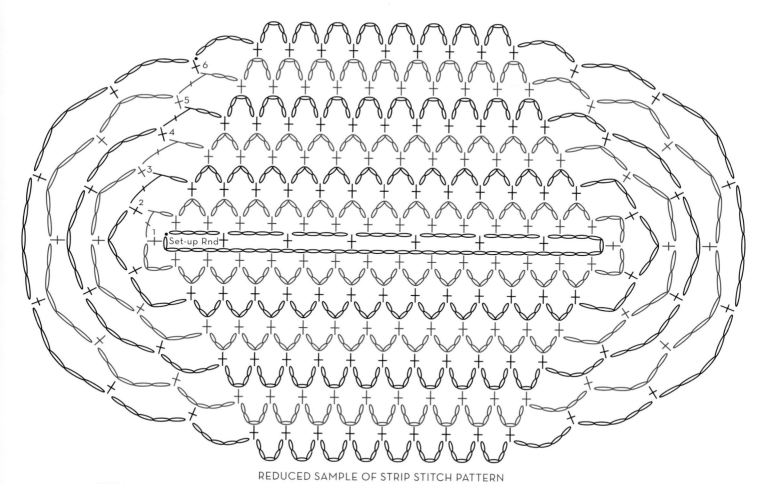

REDUCED SAMPLE OF STRIP STITCH PATTERN

STITCH KEY

⬭ = chain (ch)

• = slip stitch (sl st)

+ = single crochet (sc)

T = double crochet (dc)

LARGER STRIP

With wrong side of base strip facing up, with C, work Joining Rnd same as for smaller strip. Remove all markers on base strip.

Work Rnds 1–6 of strip stitch pattern.

Note: Use only Yarn C ch-sps while you are working the strip stitch pattern (do not crochet into Yarn A or Yarn B spaces).

FINISHING

Block scarf. Try it on and decide where to place the button. Sew on button. Use one of the holes in the center chain space as a buttonhole.

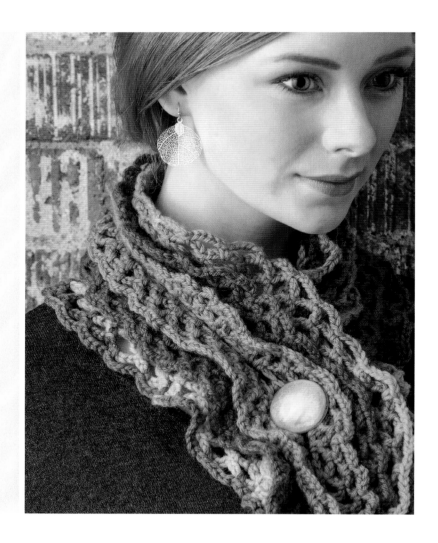

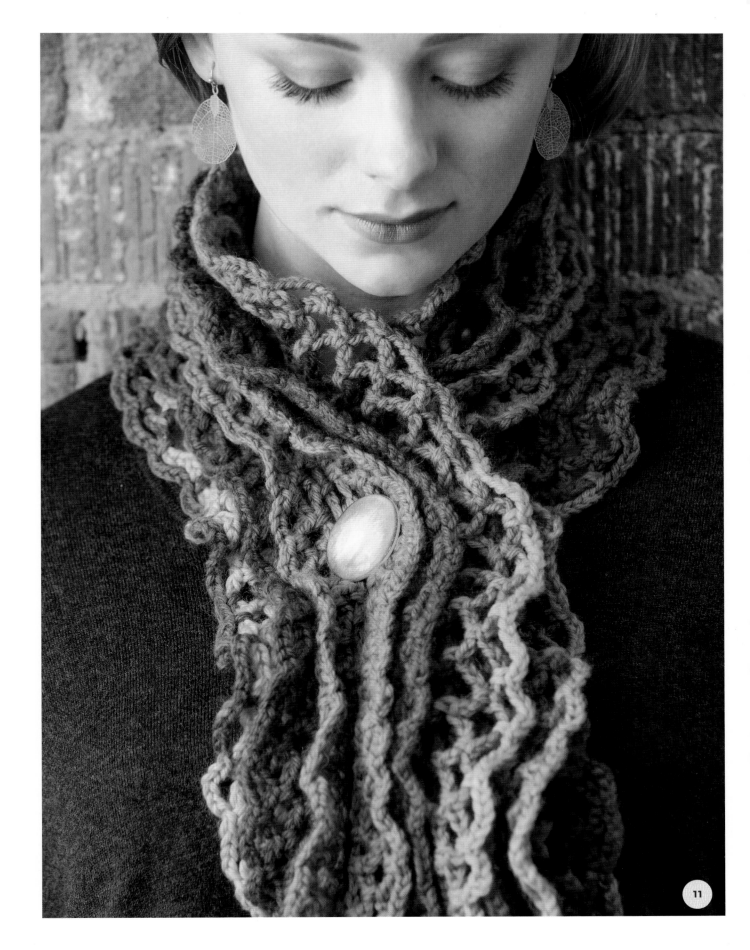

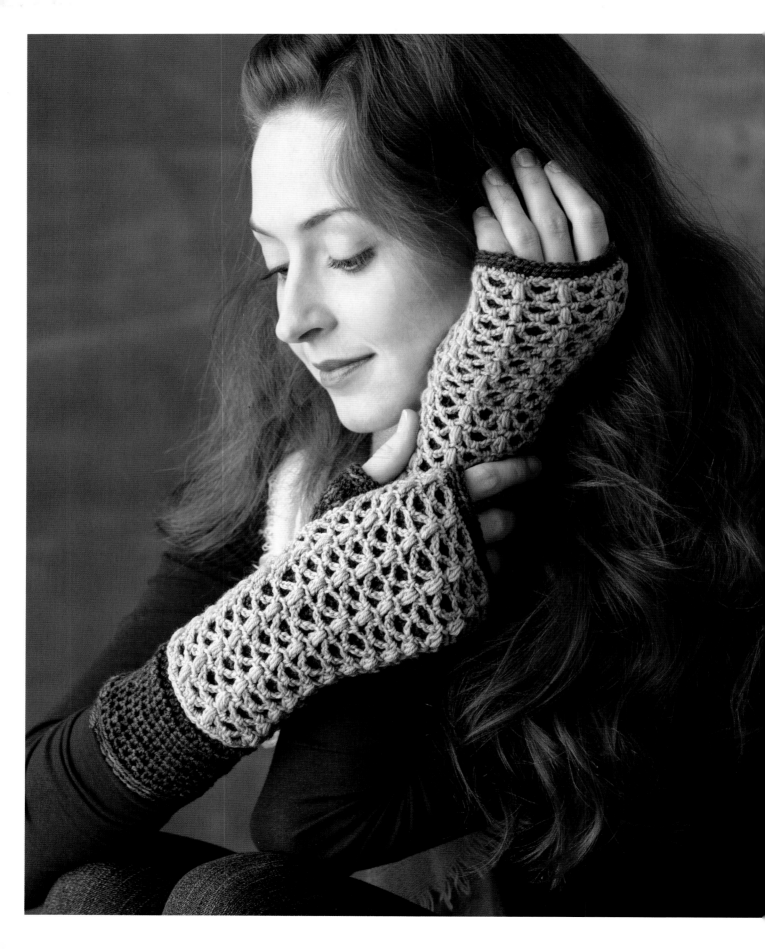

LACE *reflections*

Dress up simple fingerless gloves using multicolor or dark yarn with a light contrast color for a lace stitch second layer. Using a variety of yarn combinations—shiny and matte, wool and mohair—these are fingerless gloves for any occasion. After completing the base gloves, work single crochet to the loops of the base gloves and crochet down. No sewing required!

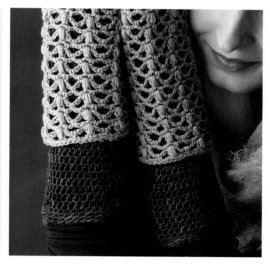

stitch guide

PUFF ST (PF)

Yo, insert hook in next st, yo and draw up a lp, [yo, insert hook in the same st, yo and draw up a lp] twice, yo and draw through all 7 lps on hook, ch 1 to secure pf.

LACE STITCH PATTERN (RNDS)
(worked over a multiple of 5 sts)

SET-UP RND: Ch 2, sk first 2 sts, *sc in next st, ch 5, sk next 2 sts, sc in next st**, ch 1, sk next st; rep from * around, ending last rep at **, sl st in first ch of beg ch-2.

RND 1: Sl st in first ch-1 sp, ch 2, pf in first ch-1 sp, *ch 2, sc in next ch-5 sp, ch 2**, pf in next ch-1 sp; rep from * around, ending last rep at **, join with a sl st in top of first pf.

RND 2: Ch 2, *sc in next ch-2 sp, ch 5, sc in next ch-2 sp**, ch 1; rep from * around, ending last rep at **, join with a sl st in first ch of beg ch-2.
Repeat Rnds 1 and 2 for pattern.

LACE STITCH PATTERN (ROWS)
(worked over a multiple of 5 sts plus 1 st)

ROW 1: Ch 5 (counts as dc, ch 2), *sc in next ch-5 sp, ch 2**, pf in next ch-1 sp, ch 2; rep from * across, ending last rep at **, dc in last sc, turn.

ROW 2: Ch 1, sc in first dc, *sc in next ch-2 sp, ch 5, sc in next ch-2 sp**, ch 1; rep from * across, ending last rep at **, sc in 3rd ch of beg ch-5, turn.

Repeat Rows 1 and 2 for pattern.

instructions

BASE GLOVE—FINGER CUFF AND PALM

With larger crochet hook and A, ch 36, join into a ring working sl st in first ch. Be careful not to twist.

Change to smaller crochet hook.

RND 1: Ch 1, sc in each ch around, join with a sl st in first sc—36 sc.

RNDS 2 AND 3: Ch 1, sc in back lp only of each sc around, join with a sl st in first sc.

RND 4: Ch 1, place marker in first ch of rnd, sk first sc, hdc in back lp only of next 35 sc, do not join. Work in a spiral, move marker up to first st of rnd as work progresses—35 hdc.

RND 5: Hdc in marked ch, hdc in each of next 35 hdc—36 hdc.

RNDS 6–11: Hdc in each hdc around.

BASE GLOVE—THUMB GUSSET

RND 12: Hdc in marked hdc, ch 14 (for thumb opening), hdc in each of next 35 hdc—36 hdc plus ch-14 loop.

RND 13: Hdc in marked hdc, hdc in each of 14 ch sts, hdc in each of next 35 hdc—50 hdc.

RND 14: Hdc2tog over next 2 sts, hdc in each of 12 hdc, hdc2tog over next 2 sts, hdc in each of next 34 hdc—48 hdc.

RND 15: Hdc2tog over next 2 sts, hdc in each of 10 hdc, hdc2tog over next 2 sts, hdc in each of next 34 hdc—46 hdc.

RND 16: Hdc2tog over next 2 sts, hdc in each of 8 hdc, hdc2tog over next 2 sts, hdc in each of next 34 hdc—44 hdc.

RND 17: Hdc2tog over next 2 sts, hdc in each of 6 hdc, hdc2tog in next 2 sts, hdc over each of next 34 hdc—42 hdc.

RND 18: Hdc2tog over next 2 sts, hdc in each of 4 hdc, hdc2tog in next 2 sts, hdc over each of next 34 hdc—40 hdc.

RND 19: Hdc2tog over next 2 sts, hdc in each of 2 hdc, hdc2tog in next 2 sts, hdc over each of next 34 hdc—38 hdc.

RND 20: [Hdc2tog over next 2 sts] twice, hdc in each of next 34 hdc—36 hdc.

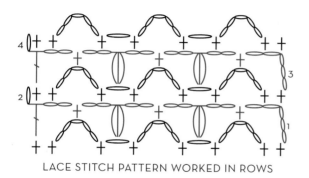

LACE STITCH PATTERN WORKED IN ROWS

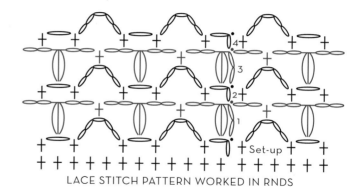

LACE STITCH PATTERN WORKED IN RNDS

STITCH KEY

◯ = chain (ch)

• = slip stitch (sl st)

✝ = single crochet (sc)

⊤ = double crochet (dc)

⬮ = puff stitch (pf)

BASE GLOVE—BODY AND ARM CUFF

RND 21: Hdc in each st around—36 hdc.

Repeat Rnd 21 until work measures 10½" (26.5 cm) from finger cuff, then cont as foll:

NEXT RND: Hdc in next 35 hdc, sc in next hdc, sl st to top of next hdc.

Work next 2 rows as foll: With larger crochet hook, ch 1, sc in back lp only of each st around, join with a sl st in first sc. Fasten off.

THUMBHOLE

SET-UP RND: With right side facing, working across opposite side of foundation ch of thumb opening, join A in first ch, sl st in each of next 13 ch, work 4 sl sts along edge of thumb gusset, join with a sl st in first sl st—18 sl sts.

RND 1: Change to smaller hook, ch 1, sc in back lp only of each sl st around, join with a sl st in first sc—18 sts.

RND 2: Ch 1, sc in back lp only of each sc around, join with a sl st in first sc.

Fasten off.

LACE FABRIC ON TOP OF BASE GLOVES

Lay base glove down with the finger cuff toward you and the thumb-hole to the right. Beg directly below the thumbhole, working in front lps of sts in Rnd 3, join B with a sl st in a st directly below thumb opening, ch 1, sc in first 8 sts, 2 sc in next st, *sc in each of next 8 sts, 2 sc in next st, rep from * around, join with a sl st in first sc—40 sc.

Work Set-up Rnd of lace stitch pattern—crochet around (see Stitch Guide).

RNDS 1–3: Work in lace stitch pattern Rnds 1 and 2 once, then work Rnd 1, turn.

Work now progresses in rows.

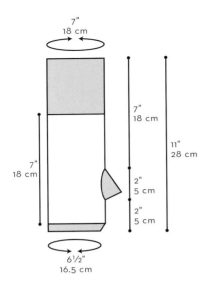

7"
18 cm

7"
18 cm

7"
18 cm

11"
28 cm

2"
5 cm

2"
5 cm

6½"
16.5 cm

ROW 4 (WS): Ch 1, sc in first pf, *sc in next ch-2 sp, ch 5, sc in next ch-2 sp**, ch 1; rep from * around, ending last rep at **, turn.

ROWS 5–12: Work in lace stitch pattern (in rows), working Rows 1 and 2 (4 times), then rep Row 1 once.

Work now progresses in rnds.

RND 13: Rep Row 1, join with a sl st in 3rd ch of beg ch-5.

RND 14: Ch 2, *sc in next ch-2 sp, ch 5, sc in next ch-2 sp, ch 1; rep from * around, ending last rep at **, join with a sl st in first ch of beg ch-2.

RNDS 15–27: Work in lace stitch pattern (in rnds), work Rnds 1 and 2 (6 times), then rep Rnd 1 once.

RND 28: Ch 1, sc in first pf, *2 sc in next ch-2 sp, sc in next sc, 2 sc in next ch-2 sp**, sc in next pf; rep from * around, ending last rep at **, join with a sl st in first sc. Fasten off.

FINISHING

Weave in ends.

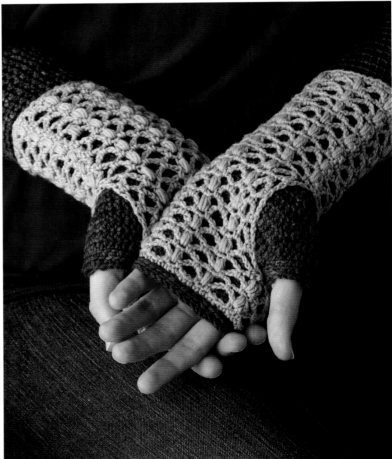

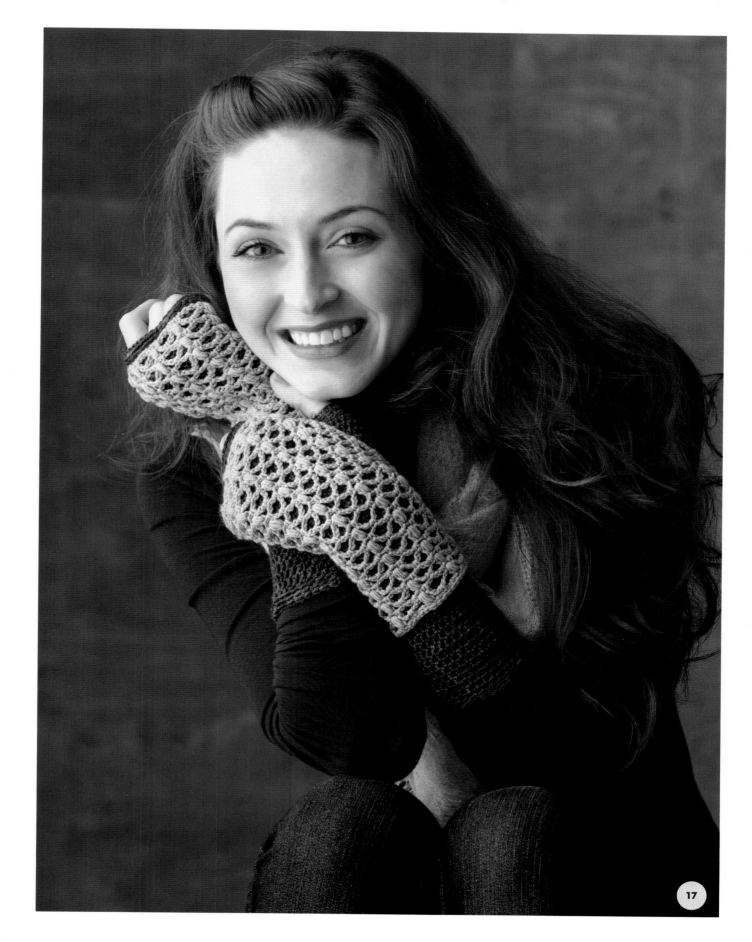

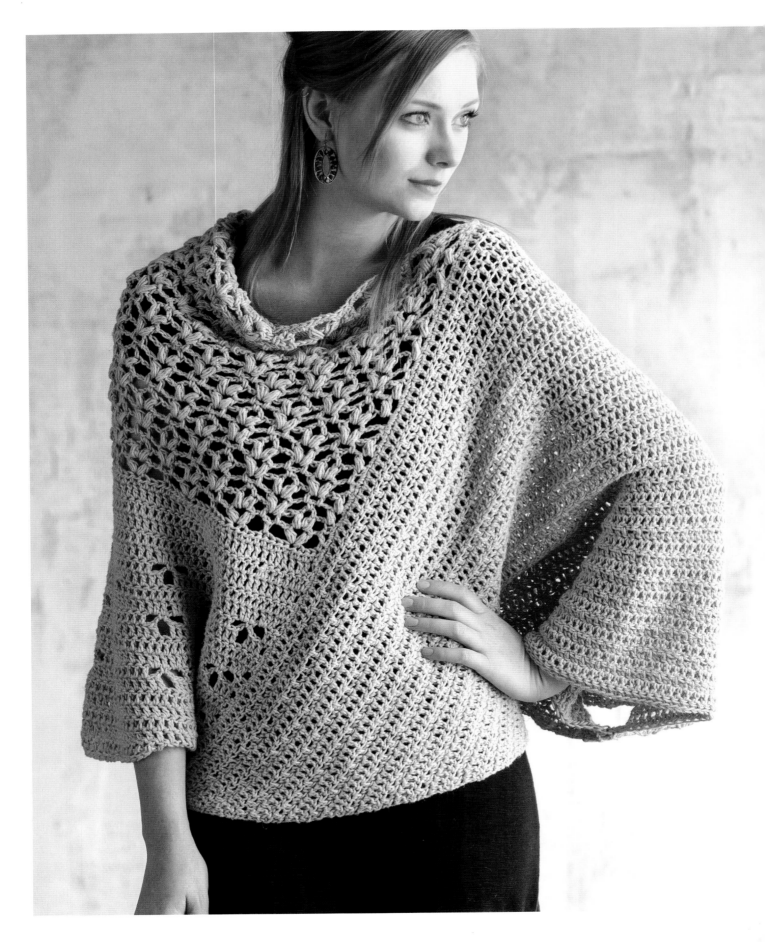

FINISHED SIZE
S–L (XL–XXL)

20" (51 cm) long as measured
flat; see Note (page 21) for
more information on sizes.

MATERIALS
yarn
Worsted weight (#4 Medium).

SHOWN HERE: Rowan Creative
Linen (50% linen, 50% cotton;
219 yd/100 g): #621 Natural, 5
(6) balls.

hook
I/9 (5.5 mm). *Adjust hook size
if necessary to obtain correct
gauge.*

notions
Darning needle; stitch markers.

GAUGE
13½ sts and 7 rows dc = 4"
(10 cm) in stitch pattern A.

1 rep (8 sts and 4 rows) = about
2½" (6.5 cm) wide and 2" (5 cm)
high in stitch pattern B.

13 sts and 8 rows = 4" (10 cm) in
stitch pattern C.

SAND *& shells*

I love unusual garments, and this is one of my favorite
pieces. It is a simple design consisting of three sections:
two rectangles and a trapezoid. The lacy pattern for
the neck lends texture and a feminine look, while the
simple double crochet is kept interesting with the added
eyelets. Sand & Shells can easily go from beach cover-
up to a day shopping on the town, to the perfect accent
for an evening out.

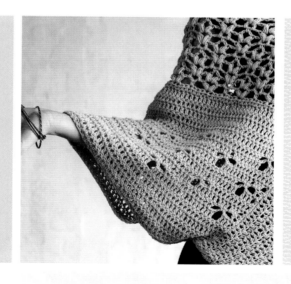

stitch guide

PUFF ST (PF)
Yo, insert hook in next st, yo and draw up a lp, (yo, insert hook in same st, yo and draw up a lp) 2 times, yo and draw through all 7 lps on hook, ch 1 to secure pf.

BEG DC2TOG
Ch 2, yo, insert hook in next st, draw up a lp (3 lps on hook), yo, draw through first 2 lps on hook, yo, draw through last 2 lps on hook.

DC2TOG
Yo, insert hook in next st, draw up a lp, yo, draw through first 2 lps on hook, yo, insert hook in next st, draw up a lp, yo, draw through first 2 lps on hook, yo, draw through all 3 lps on hook.

HDC2TOG
Yo, insert hook in next st, draw up a lp, yo, insert hook in next st, draw up a lp, yo, draw through all 5 lps on hook.

SC-BLO
Work sc through back loop only.

HDC-BLO
Work hdc through back loop only.

FOUNDATION HALF DOUBLE CROCHET (FHDC)
Ch 3, yo, insert hook in 3rd ch from hook, yo and draw up a lp (3 lps on hook), yo and draw through 1 lp (1 ch made), yo and draw through all lps on hook (one fhdc made), *yo, insert hook under the 2 lps of the "chain" stitch from previous fhdc and draw up lp, yo and draw through 1 lp (1 ch made), yo and draw through all lps on hook; rep from * for length of foundation.

STITCH PATTERN A
(worked over a multiple of 18 sts, plus 9 sts)

SET-UP ROW: Ch 3 (counts as dc here and through-out), *dc in each of next 3 sts, ch 3, sk next st**, dc in each of next 14 sts; rep from * across, ending last rep at **, dc in each of last 4 sts, turn.

ROW 1: Ch 3, *dc in next dc, ch 2, sc in next ch-3 sp, ch 2, sk next 2 dc**, dc in each of next 12 dc; rep from * across, ending last rep at **, dc in each of last 2 dc, turn.

ROW 2: Ch 3, *dc in next dc, 2 dc in next ch-2 sp, dc in next sc, 2 dc in next ch-2 sp**, dc in each of next 6 dc, ch 3, sk next dc, dc in each of next 5 dc; rep from * across, ending last rep at **, dc in each of last 2 dc, turn.

ROW 3: Ch 3, *dc in each of next 10 dc, ch 2, sk next 2 dc, sc in next ch-3 sp, ch 2, sk next 2 dc, dc in each of next 3 dc; rep from * across, dc in each of last 8 dc, turn.

ROW 4: Ch 3, *dc in each of next 3 dc, ch 3, sk next dc**, dc in each of next 6 dc, 2 dc in next ch-2 sp, dc in next sc, 2 dc in next ch-2 sp, dc in each of next 3 dc; rep from * across, ending last rep at **, dc in each of last 4 dc, turn.

Repeat Rows 1–4 for pattern.

STITCH PATTERN B
(worked over a multiple of 8 sts, plus 1 st)

SET-UP ROW: Ch 1, sc in first st, *sk next 3 sts, ch 2, (pf, ch 2, pf) in next st, ch 2, sk next 3 sts, sc in next st; rep from * across, turn.

ROW 1: Ch 2, dc in ch-2 sp, *ch 2, (pf, ch 2, pf) in next ch-2 sp bet 2 pfs, ch 2**, dc2tog over next 2 ch-2 sps; rep from * across, ending last rep at **, dc2tog over next ch-2 sp and last sc, turn.

ROW 2: Ch 4 (counts as dc, ch 1 here and throughout), pf in first dc2tog, *ch 2, sk next ch-2 sp, sc in next ch-2 sp bet 2 pfs, ch 2, sk next ch-2 sp**, (pf, ch 2, pf) in next dc2tog; rep from * across, ending last rep at **, (pf, ch 1, dc) in last dc, turn.

ROW 3: Ch 4, pf in first ch-1 sp, ch 2, *dc2tog over next 2 ch-2 sps, ch 2**, (pf, ch 2, pf) in ch-2 sp bet 2 pfs, ch 2; rep from * across, ending last rep at **, (pf, ch 1, dc) in last ch-1 sp, turn.

ROW 4: Ch 1, sc in first dc, *ch 2, sk next ch-2 sp, (pf, ch 2, pf) in next dc2tog, ch 2, sk next ch-2 sp**, sc in next ch-2 sp bet 2 pfs; rep from * across, ending last rep at **, sc in 3rd ch of beg ch-4, turn.

Repeat Rows 1–4 for pattern.

STITCH PATTERN C
(worked over a multiple of 2 sts, plus 1 st)

ROW 1 (RS): Beg-dc2tog over first 2 sts, *sc-blo in next st, dc in both lps of next st; rep from * across to last 3 sts, sc-blo in next st, working in both lps of sts, dc-2tog over last 2 sts, turn.

ROW 2: Beg-dc2tog over first 2 sts, dc in each st across to last 2 sts, dc2tog over last 2 sts, turn.

Repeat Rows 1 and 2 for pattern.

note

This is a poncho-like top. Make one rectangle shape with two sections in two stitch patterns. Then work section C from the edge of the rectangle shape. There is a 5" (12.5 cm) difference between the smaller and larger sizes in the width of the rectangle section (which is half of the body). I asked many people of different sizes to try on this garment. The smaller size fits women who wear sizes S–L, and the larger size fits women who wear sizes XL–XXL.

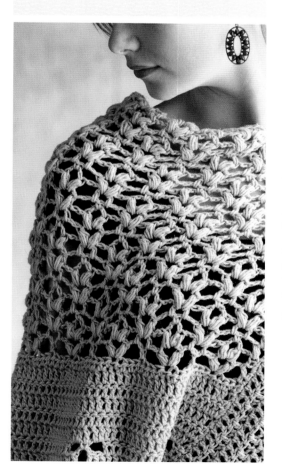

instructions

SECTION A

ROW 1 (RS): Work 81 (99) fhdc (see Stitch Guide).

ROWS 2-6: Ch 3 (counts as dc here and throughout), sk first st, dc in each st across, turn—81 (99) dc.

ROWS 7-16: Working in st patt A, work Set-up Row, then Rows 1–4 (twice), then rep Row 1.

ROW 17: Ch 3, *dc in next dc, 2 dc in next ch-2 sp, dc in next sc, 2 dc in next ch-2 sp**, dc in each of next 12 dc; rep from * across, ending last rep at **, dc in each of next 2 dc, turn.

ROWS 18-21: Ch 3 (counts as dc), sk first st, dc in each of next st across, turn.

SIZES S–L ONLY

ROW 22: Ch 2 (counts as hdc), sk first dc, hdc in each of next dc across.

SIZES XL–XXL ONLY

ROW 22: Ch 1 (does not count as a st), hdc in next st (counts as hdc-2tog), hdc in each dc across to last 2 sts, hdc2tog over last 2 sts—97 sts.

Note: *There are 2 sts decreased at the end of section A for sizes XL–XXL because this is the adjustment needed to work st patt B. The width of section A and section B is slightly different. Adjust the width of these sections as needed when blocking the garment.*

Do not fasten off. Work section B as follows.

STITCH KEY

- ⬭ = chain (ch)
- • = slip stitch (sl st)
- + = single crochet (sc)
- † = double crochet (dc)
- ⋔ = beg dc2tog
- ⋀ = dc2tog
- ⬭ = puff stitch (pf)
- ⌒ = worked in back loop only (blo)

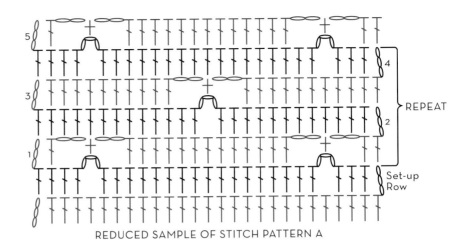

REDUCED SAMPLE OF STITCH PATTERN A

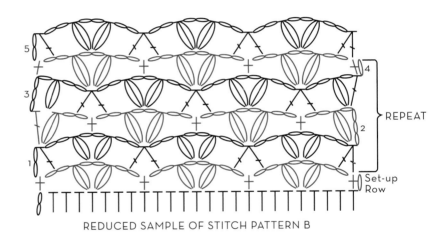

REDUCED SAMPLE OF STITCH PATTERN B

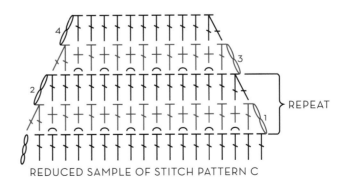

REDUCED SAMPLE OF STITCH PATTERN C

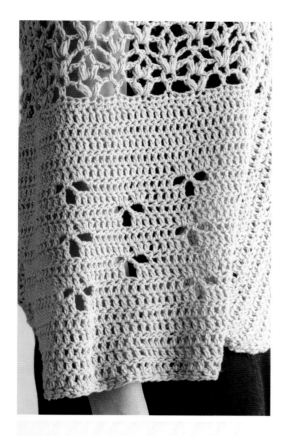

SECTION B

ROW 1 (RS): Work in st patt B Set-up Row.

ROWS 2–22: Work in st patt B Rows 1–4 (5 times), then rep Row 1.

ROW 23: Ch 1, sc in first st, *2 sc in next ch-2 sp, 4 sc in next ch-2 sp bet 2 pfs, 2 sc in next ch-2 sp; rep from * across, sc in last dc2tog. Fasten off.

SECTION C

Fold piece in half lengthwise (**figure 1** on page 24).

ROW 1: Working in row-end sts across side edge of sections A and B, join yarn in first st at end of Row 1 (**figure 2** on page 24), ch 1, work 39 sc evenly spaced across edge of section A, work 39 sc evenly spaced across edge of section B to corner B. Do not fasten off. With piece folded, sk last row of section B, starting in first row-end st at corner C, work 39 sc evenly spaced across other side edge of section B, work 39 sc evenly spaced across side edge of section A, ending at corner D, turn—156 sc (**figure 2** on page 24).

ROW 2: Ch 3 (counts as dc), sk first sc, dc in each sc across, turn.

ROWS 3–42: Work in st patt C Rows 1 and 2 twenty times—76 sts at end of last row.

ROW 43: Ch 2 (counts as hdc), sk first st, hdc-blo in each dc across.

Fasten off.

FINISHING

The open edge of section B is for the neck. Secure the neck at the corner of the neck edge when weaving in ends.

Sew the open edge of section A, leaving 8" (20.5 cm) open for cuff (**figure 3** on page 24).

If you prefer to have more open space around your body, do not sew this edge. Or just leave 8" (20.5 cm) open for cuff and sew ¼"–½" (6–13 mm) to make cuff.

Sew the open armhole edge of section C, leaving 8" (20.5 cm) open for cuff (**figure 3** on page 24).

Weave in ends.

Wash gently by hand, roll in towel to remove excess water, then block flat.

figure 1

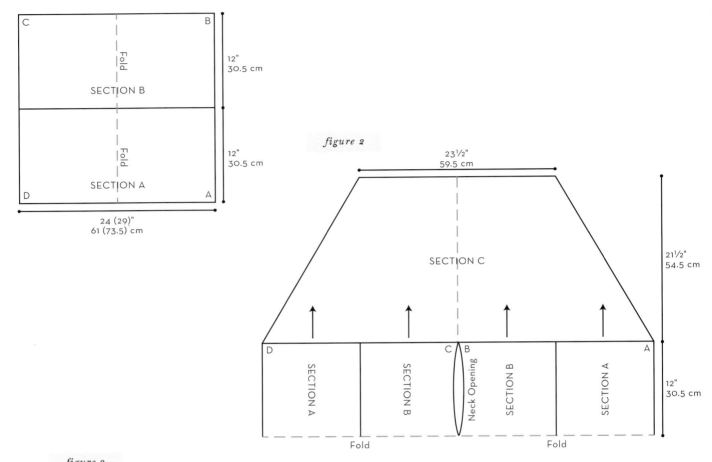

C B

Fold

SECTION B

12"
30.5 cm

Fold

SECTION A

12"
30.5 cm

D A

24 (29)"
61 (73.5) cm

figure 2

23½"
59.5 cm

SECTION C

21½"
54.5 cm

D SECTION A SECTION B C B Neck Opening SECTION B SECTION A A

12"
30.5 cm

Fold Fold

figure 3

12 (14½)"
30.5 (37) cm

21"
53.5 cm

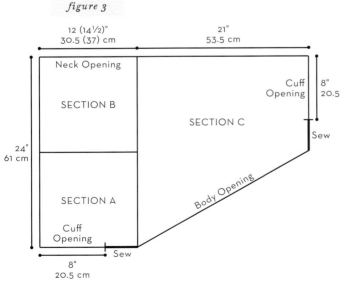

Neck Opening

SECTION B

Cuff
Opening

8"
20.5

SECTION C

24"
61 cm

Sew

SECTION A

Body Opening

Cuff
Opening

Sew

8"
20.5 cm

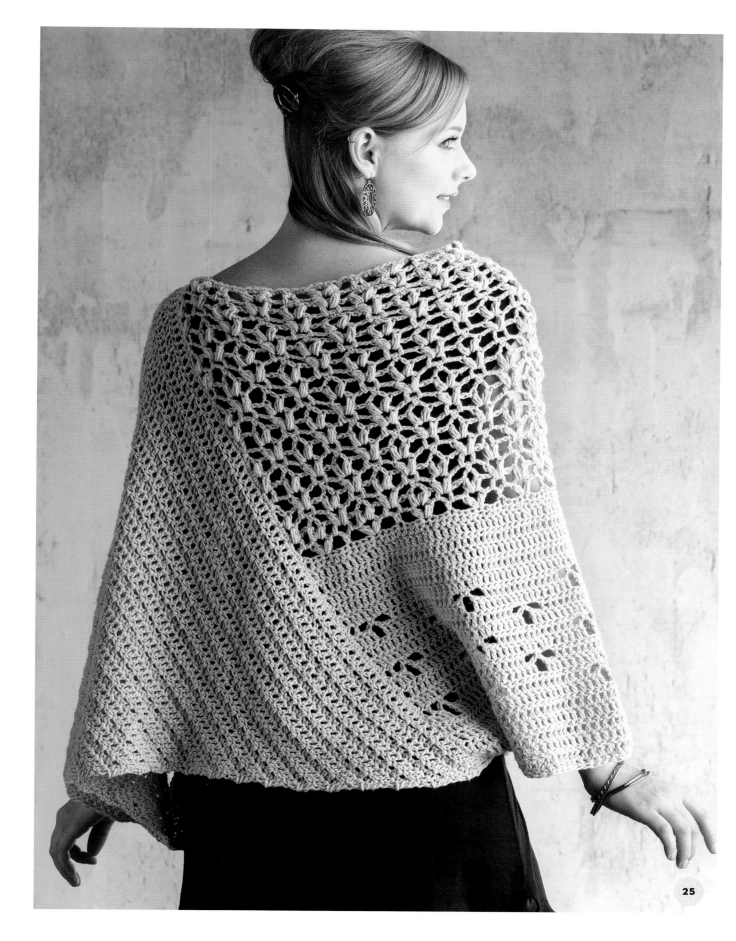

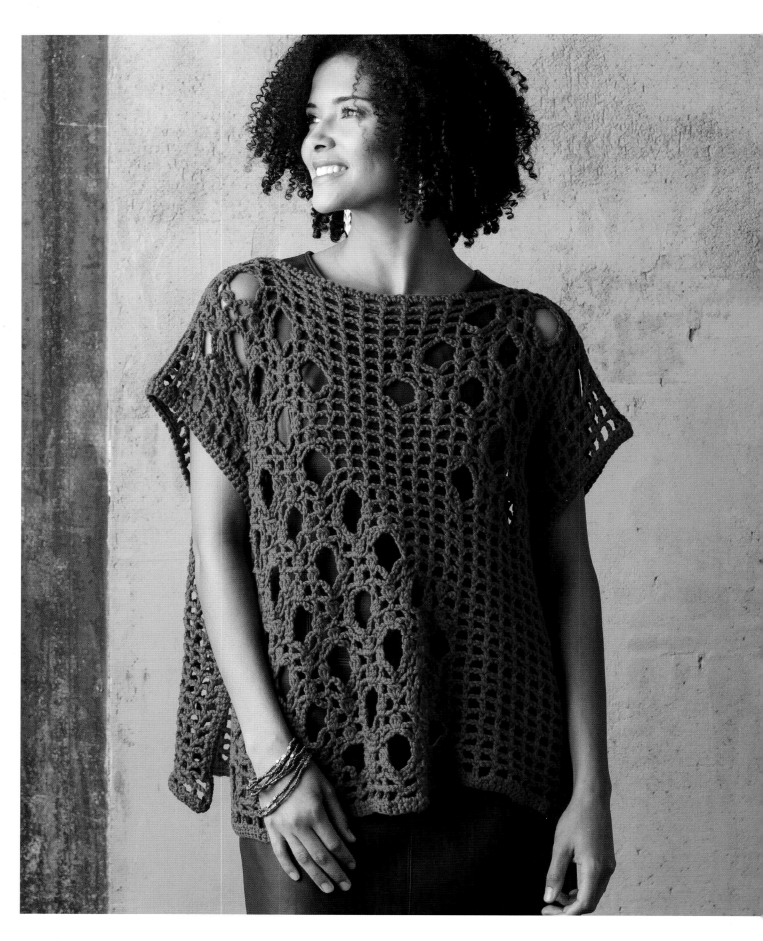

FINISHED SIZE
S–L (XL–XXL)

27½ (30½)" (70 [77.5] cm) wide
and 24 (25½)" (61 [65] cm) long
as measured flat.

MATERIALS

yarn

Worsted weight (#4 Medium).

SHOWN HERE: Universal Yarn
Cotton Supreme (100% cotton;
180 yd/100 g): #508 Brick, 4 (5)
skeins.

hook

I/9 (5.5 mm). *Adjust hook size
if necessary to obtain correct
gauge.*

notions

Darning needle; stitch markers.

GAUGE
15 sts (5 squares) and 6
rows = 4" (10 cm) in square
stitch pattern.

bridges

I love circles, and when I found this circle pattern, I knew
I had to design with it. When I added the small mesh
square, I found the perfect balance between round and
square. How can one not think of bridges when looking
at the texture of this piece? You can use a double strand
of sportweight yarn instead of using a single strand of
worsted weight; this will produce a crocheted fabric
that will be lighter looking and have more texture.

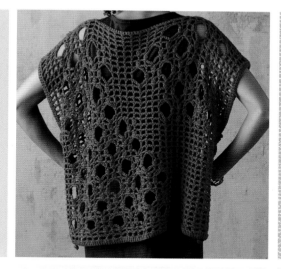

stitch guide

3 DOUBLE CROCHET CLUSTER (3DC-CL)

Yo, insert hook in st, draw up a lp, yo, draw through 2 lps on hook, [yo, insert hook in the same st, draw up a lp, yo, draw through first 2 lps on hook] twice, yo, draw through all 4 lps on hook.

SQUARE STITCH PATTERN
(worked over a multiple of 3 sts, plus 1 st)

BASE: Make the ch a multiple of 3 sts.

SET-UP ROW: Ch 5 (counts as dc and ch 2), dc in 8th ch from hook, *ch 2, sk next 2 ch, dc in next ch; rep from * across, turn.

ROW 1: Ch 3 (counts as dc), *ch 2, dc in next dc; rep from * across, turn.

Rep Row 1 for pattern.

instructions

BODY
(make 2)

Ch 99 (111), work square stitch pattern Set-up Row (see Stitch Guide; total 33 [37] squares), then work square stitch pattern Row 1 (1 [3] times).

Note: *If you like a longer garment, work more rows of square stitch pattern Row 1.*

Now start working a combination of square stitch pattern and circle stitch pattern. Markers are used between square stitch pattern and circle stitch pattern. They will move up to the next row every time you work a stitch that has a marker.

Note: *The pattern doesn't say "skip next ch-2 sp," but all ch-2 sps should be skipped. When pattern says to "work in next st," you should skip next ch-2 sp and work in the next dc, 3dc-cl, or sc as applicable.*

ROW 1 (RS): Ch 3 (counts as dc here and throughout), *ch 2, dc in next dc *; rep from * to * 2 (3) times, place marker in last dc made, [ch 4, sc in next st, ch 4, dc in next st, ch 2, 3dc-cl in next st, ch 2, dc in next st] 4 times, ch 4, sc in next st, ch 4, dc in next st, pm; rep from * to * across, turn.

ROW 2: Ch 3, *ch 2, dc in next st*; rep from * to * to first marker (the last dc worked is the marked st) and move marker up to last dc made, [ch 8, sk next sc, 3dc-cl in next st, ch 2, dc in next st, ch 2, 3dc-cl in next st] 4 times, ch 8, sk next sc, dc in next st and move 2nd marker up to dc just made; rep from * to * across, turn.

Note: *Continue moving markers up each row in this manner.*

ROW 3: Ch 3, *ch 2, dc in next st*; rep from * to * to first marker, [ch 2, sc in next ch-8 sp, ch 2, dc in next st, ch 2, 3dc-cl in next st, ch 2, dc in next st] 4 times, ch 2, sc in next ch-8 sp; rep from * to * across, turn.

ROW 4: Ch 3, *ch 2, dc in next st*; rep from * to * to first marker, [ch 2, 3dc-cl in next st, ch 2, dc in next st, ch 4, sc in next st, ch 4, dc in next st] 4 times, ch 2, 3dc-cl in next st; rep from * to * across, turn.

ROW 5: Ch 3, *ch 2, dc in next st*; rep from * to * to first marker, [ch 2, dc in next st, ch 2, 3dc-cl in next st, ch 8, sk next sc, 3dc-cl in next st] 4 times; rep from * to * across, turn.

STITCH KEY

◯ = chain (ch)

✝ = single crochet (sc)

| = double crochet (dc)

⬮ = 3 double crochet cluster (3dc-cl)

SQUARES PATTERN

Set-up Row

REDUCED SAMPLE OF PATTERN

ROW 6: Ch 3, *ch 2, dc in next st*; rep from * to * to first marker, [ch 2, 3dc-cl in next st, ch 2, dc in next st, ch 2, sc in next ch-8 sp, ch 2, dc in next st] 4 times, ch 2, 3dc-cl in next st; rep from * to * across, turn.

ROWS 7–12: Repeat Rows 1–6.

ROW 13: Ch 3, *ch 2, dc in next st*; rep from * to * to first marker, [ch 4, sc in next st, ch 4, dc in next st, ch 2, 3dc-cl in next st, ch 2, dc in next st] 3 times, ch 4, sc in next st, ch 4, dc in next st, pm (replace 2nd marker); rep from * to * across, turn.

ROW 14: Ch 3, *ch 2, dc in next st*; rep from * to * to first marker, [ch 8, sk next sc, 3dc-cl in next st, ch 2, dc in next st, ch 2, 3dc-cl in next st] 3 times, ch 8, sk next sc, dc in next st; rep from * to * across, turn.

ROW 15: Ch 3, *ch 2, dc in next st*; rep from * to * to first marker, [ch 2, sc in next ch-8 sp, ch 2, dc in next st, ch 2, 3dc-cl in next st, ch 2, dc in next st] 3 times, ch 2, sc in next ch-8 sp; rep from * to * across, turn.

ROW 16: Ch 3, *ch 2, dc in next st*; rep from * to * to first marker, [ch 2, 3dc-cl in next st, ch 2, dc in next st, ch 4, sc in next st, ch 4, dc in next st] 3 times, ch 2, 3dc-cl in next st; rep from * to * across, turn.

ROW 17: Ch 3, *ch 2, dc in next st*; rep from * to * to first marker, [ch 2, dc in next st, ch 2, 3dc-cl in next st, ch 8, sk next sc, 3dc-cl in next st] 3 times; rep from * to * across, turn.

ROW 18: Ch 3, *ch 2, dc in next st*; rep from * to * to first marker, [ch 2, 3dc-cl in next st, ch 2, dc in next st, ch 2, sc in next ch-8 sp, ch 2, dc in next st] 3 times, ch 2, 3dc-cl in next st; rep from * to * across, turn.

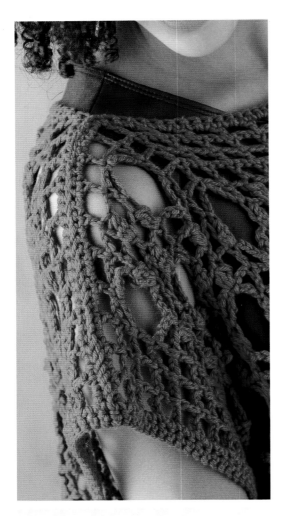

ROW 19: Ch 3, *ch 2, dc in next st*; rep from * to * to first marker, [ch 4, sc in next st, ch 4, dc in next st, ch 2, 3dc-cl in next st, ch 2, dc in next st] twice, ch 4, sc in next st, ch 4, dc in next st, pm (replace 2nd marker from previous row), [ch 2, dc in next st] 7 times, place new (3rd) marker, [ch 4, sc in next st, ch 4, dc in next st, ch 2, 3dc-cl in next st, ch 2, dc in next st] twice, ch 4, sc in next st, ch 4, dc in next st, place new (4th) marker; rep from * to * across, turn—total 4 markers on the fabric.)

ROW 20: Ch 3, *ch 2, dc in next st*; rep from * to * to first marker, [ch 8, sk next sc, 3dc-cl in next st, ch 2, dc in next st, ch 2, 3dc-cl in next st] twice, ch 8, sk next sc, dc in next st; rep from * to * to next marker, [ch 8, sk next sc, 3dc-cl in next st, ch 2, dc in next st, ch 2, 3dc-cl in next st] twice, ch 8, sk next sc, dc in next st; rep from * to * across, turn.

ROW 21: Ch 3, *ch 2, dc in next st*; rep from * to * to first marker, [ch 2, sc in next ch-8 sp, ch 2, dc in next st, ch 2, 3dc-cl in next st, ch 2, dc in next st] twice, ch 2, sc in next ch-8 sp; rep from * to * to next marker, [ch 2, sc in next ch-8 sp, ch 2, dc in next st, ch 2, 3dc-cl in next st, ch 2, dc in next st] twice, ch 2, sc in next ch-8 sp; rep from * to * across, turn.

ROW 22: Ch 3, *ch 2, dc in next st*; rep from * to * to first marker, [ch 2, 3dc-cl in next st, ch 2, dc in next st, ch 4, sc in next st, ch 4, dc in next st] twice, ch 2, 3dc-cl in next st, ch 2; rep from * to * to next marker, [ch 2, 3dc-cl in next st, ch 2, dc in next st, ch 4, sc in next st, ch 4, dc in next st] twice, ch 2, 3dc-cl in next st; rep from * to * across, turn.

ROW 23: Ch 3, *ch 2, dc in next st*; rep from * to * to first marker, [ch 2, dc in next st, ch 2, 3dc-cl in next st, ch 8, sk next sc, 3dc-cl in next st] twice; rep from * to * to next marker, [ch 2, dc in next st, ch 2, 3dc-cl in next st, ch 8, sk next sc, 3dc-cl in next st] twice; rep from * to * across, turn.

ROW 24: Ch 3, *ch 2, dc in next st*; rep from * to * to first marker, [ch 2, 3dc-cl in next st, ch 2, dc in next st, ch 2, sc in next ch-8 sp, ch 2, dc in next st] twice, ch 2, 3dc-cl in next st; rep from * to * to next marker, [ch 2, 3dc-cl in next st, ch 2, dc in next st, ch 2, sc in next ch-8 sp, ch 2, dc in next st] twice, ch 2, 3dc-cl in next st; rep from * to * across, turn.

ROW 25: Ch 3, *ch 2, dc in next st*; rep from * to * to first marker, [ch 4, sc in next st, ch 4, dc in next st, ch 2, 3dc-cl in next st, ch 2, dc in next st] twice, ch 4, sc in next st, ch 4, dc in next st, [ch 2, dc in next st] 3 times, pm (replace 3rd marker), [ch 4, sc in next st, ch 4, dc in next st, ch 2, 3dc-cl in next st, ch 2, dc in next st] twice, ch 4, sc in next st, ch 4, dc in next st, pm (replace 4th marker); rep from * to * across, turn.

ROWS 26–30: Repeat Rows 20–24.

ROW 31: Ch 3, *ch 2, dc in next st*; rep from * to * to first marker, ch 4, sc in next st, ch 4, dc in next st, ch 2, 3dc-cl in next st, ch 2, dc in next st, ch 4, sc in next st, ch 4, dc in next st, pm (replace 2nd marker), [ch 2, dc in next st] 11 times, pm (replace 3rd marker), [ch 4, sc in next

st, ch 4, dc in next st, ch 2, 3dc-cl in next st, ch 2, dc in next st] twice, ch 4, sc in next st, ch 4, dc in next st, pm (replace 4th marker); rep from * to * across, turn.

ROW 32: Ch 3, *ch 2, dc in next st*; rep from * to * to first marker, [ch 8, sk next sc, 3dc-cl in next st, ch 2, dc in next st, ch 2, 3dc-cl in next st] twice, ch 8, sk next sc, dc in next st, *ch 2, dc in next st*; rep from * to * to next marker, ch 8, sk next sc, 3dc-cl in next st, ch 2, dc in next st, ch 2, 3dc-cl in next st, ch 8, sk next sc, dc in next st; rep from * to * across, turn.

ROW 33: Ch 3, *ch 2, dc in next st*; rep from * to * to first marker, [ch 2, sc in next ch-8 sp, ch 2, dc in next st, ch 2, 3dc-cl in next st, ch 2, dc in next st, ch 2, sc in next ch-8 sp, ch 2, dc in next st; rep from * to * to next marker, [ch 2, sc in next ch-8 sp, ch 2, dc in next st, ch 2, 3dc-cl in next st, ch 2, dc in next st] twice, ch 2, sc in next ch-8 sp; rep from * to * across, turn.

ROW 34: Ch 3, *ch 2, dc in next st; rep from * across, turn.

ROW 35: Ch 1, sc in first dc, *2 sc in next ch-2 sp, sc in next st; rep from * across.

Fasten off.

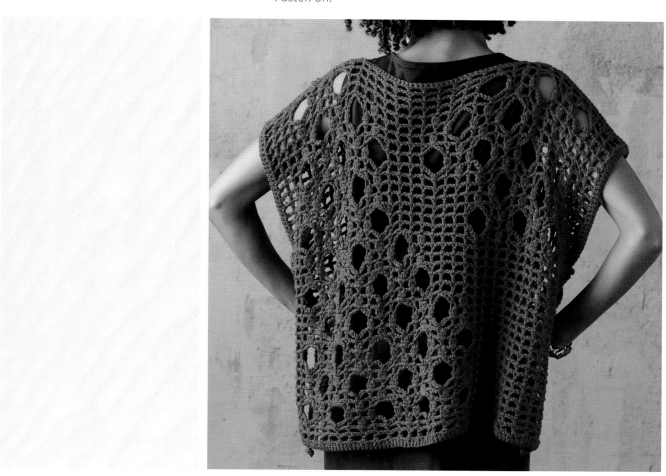

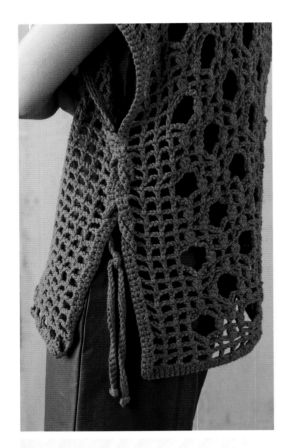

FINISHING

Measure center 11 (13)" (28 [33] cm) of the last row for the neckline and place markers on each side.

Sew the front to back across shoulders, leaving neckline open.

EDGING AROUND BODY
(on the Bottoms and Sides)

RND 1: With right side facing, working across opposite side of foundation ch, join yarn in bottom right-hand corner of Front, ch 1, sc in first ch, ** *2 sc in next ch-2 sp, sc in next ch at base of dc; rep from * across to next corner, 2 sc in corner st, working across right side of piece, working in row-end st, work 2 sc in each row-end dc across Front, sc in last row-end sc on Front, sc in next row-end sc on Back, then 2 sc in each row-end dc across side of Back to bottom corner, 2 sc in corner ch; rep from ** once, sc in the ch at corner, join with a sl st in first sc.

RND 2: Ch 1, sc in each sc around, working 2 sc in each corner, join with a sl st in first sc. Fasten off.

CORD
(make 2)

Ch 125, sl st in 2nd ch from hook and in each ch across. Fasten off.

Place markers 9" (23 cm) below shoulder on both Front and Back sides. Place markers 7" (18 cm) above bottom edge on both Front and Back sides.

Weave cords shoelace style through the square spaces from top marker down to bottom marker. Tie ends together (see photo). Tie each end of each tie in an overhand knot.

Note: *If you prefer not to use ties, sew sides together bet markers.*

Weave in ends. Block finished garment.

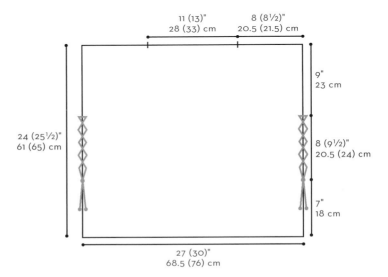

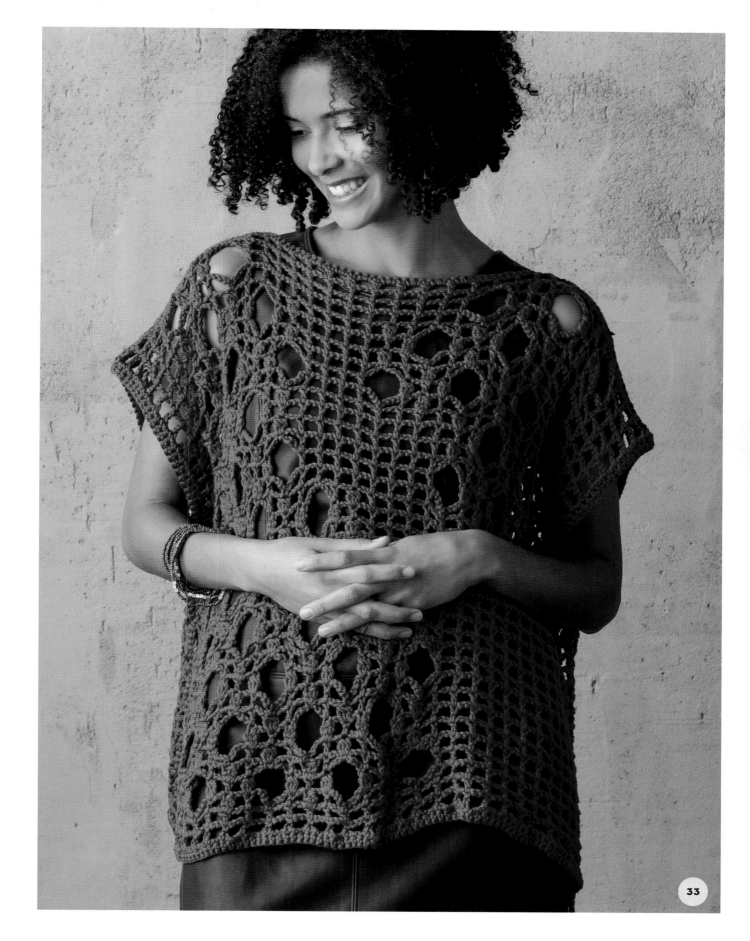

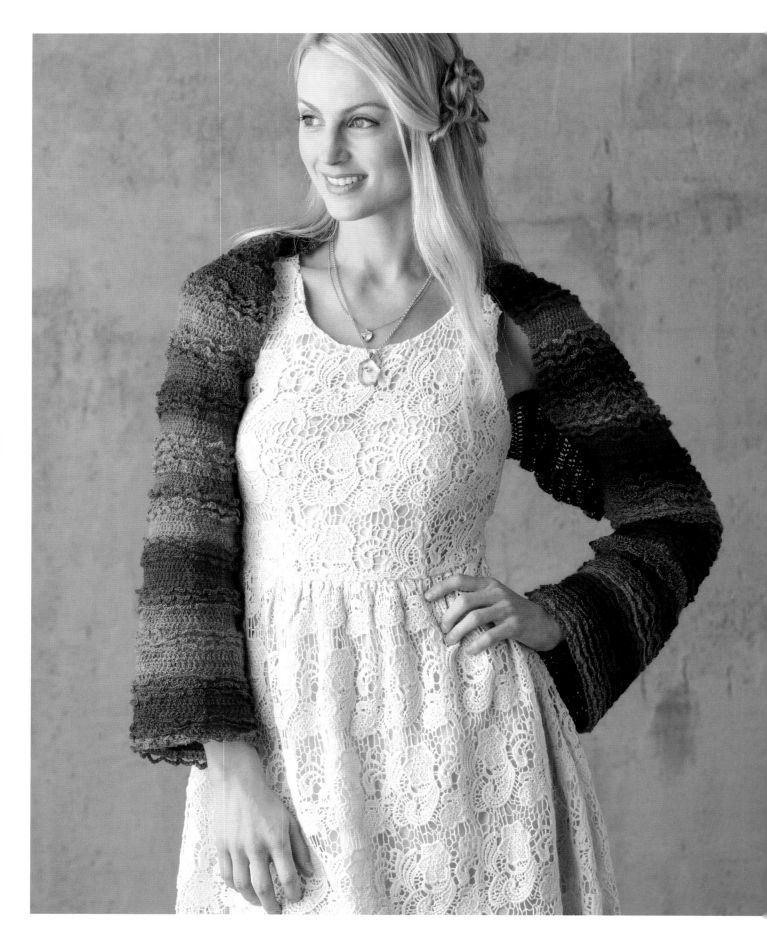

FINISHED SIZE
S–M (L, XL–XXL)

14 (15½, 17)" (35.5 [39.5, 43] cm)
wide and 57 (58½, 60)" (145
[148.5, 152.5] cm) long.

MATERIALS
yarn
Fingering weight (#1 Super
Fine).

SHOWN HERE: Wisdom Yarns
Poems Sock (75% superwash
wool, 25% nylon; 459
yd/100 g): #959 Grape Arbor,
3 balls.

hook
G/7 (4.5 mm) and I/9 (5.5 mm).
*Adjust hook size if necessary
to obtain correct gauge.*

notions
14 buttons (½" [1.3 cm] in
diameter); darning needle;
stitch markers.

GAUGE
With smaller hook, 18 sts and
10 rows dc = 4" (10 cm), after
blocking.

I wanted to create an easy design with colors, so I used a self-striping yarn and let the pattern highlight the yarn. The fabric is a simple combination of chain stitch lace and double crochet. The chain lace sections vary in length creating a whimsical, asymmetrical look. A simple rectangle with buttons, this piece can be worn as a shawl or a shrug.

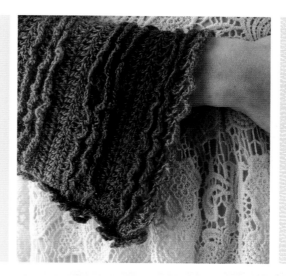

stitch guide

LACE CHAINS PATTERN
(worked over a multiple of 3 sts plus 1 st)

ROW 1 (RS): Sl st in front loop only (flo) of first st, *ch 6, sk next 2 sts, sl st in flo of next st; rep from * across to last 3 sts, ch 6, sk next 2 sts, sc in last st, turn.

ROW 2: Ch 3 (counts as dc), working in both lps of sts, dc in each dc across, turn.

Note: *Dc are worked as regular (insert hook through 2 loops), even in the sts already worked in for sl sts in previous row.*

Repeat Rows 1 and 2 for pattern.

DOUBLE CROCHET ROW
(any number of sts)

Ch 3 (counts as dc), dc in each dc across, turn.

Note: *These rows are worked between lace chains pattern rows.*

instructions

With larger hook, ch 67 (73, 79).

ROW 1: Change to smaller hook, dc in 5th ch from hook (first 3 chs count as first dc), dc in each ch across, turn—64 (70, 76) dc.

Then work sections 1–6 as foll:

Note: *The difference in each section is the number of rows of chain lace stitch worked, which starts short and gets longer in each section. If you would prefer an even length of chain lace for all of the shawl/ shrug, just keep repeating section 1 until piece measures 57 (59, 61)" (145 [150, 155] cm) long from beg.*

SECTION 1

ROWS 2–52: *Work lace chains pattern 3 times, then work 2 rows of double crochet row; rep from * 9 more times.

SECTION 2

ROWS 53–73: *Work lace chains pattern 5 times, then work 2 rows of double crochet row; rep from * 2 more times.

SECTION 3

ROWS 74–92: *Work lace chains pattern 8 times, then work 2 rows of double crochet row; rep from * 1 more time.

SECTION 4

ROWS 93–107: Work lace chains pattern 12 times, then work 2 rows of double crochet row.

SECTION 5

ROWS 108–126: Work lace chains pattern 17 times, then work 2 rows of double crochet row.

SECTION 6

ROWS 127–143 (147, 151): Work lace chains pattern 17 (21, 25) times. Do not work 2 rows of double crochet row at the end of this section.

Note: *If you would like a longer or shorter length, work more or fewer repeats of lace chains pattern.*

Fasten off.

STITCH KEY

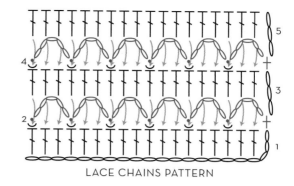

- ⬭ = chain (ch)
- • = slip stitch (sl st)
- ✝ = single crochet (sc)
- ✝ = double crochet (dc)
- ‿ = worked in front loop only (flo)

LACE CHAINS PATTERN

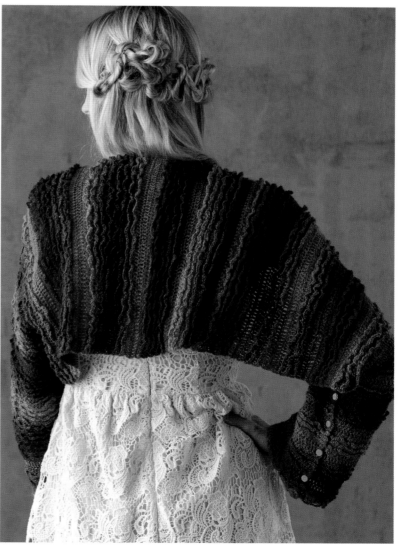

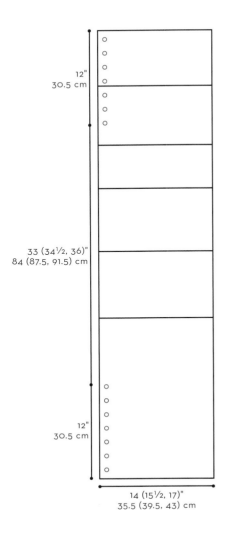

12"
30.5 cm

33 (34½, 36)"
84 (87.5, 91.5) cm

12"
30.5 cm

14 (15½, 17)"
35.5 (39.5, 43) cm

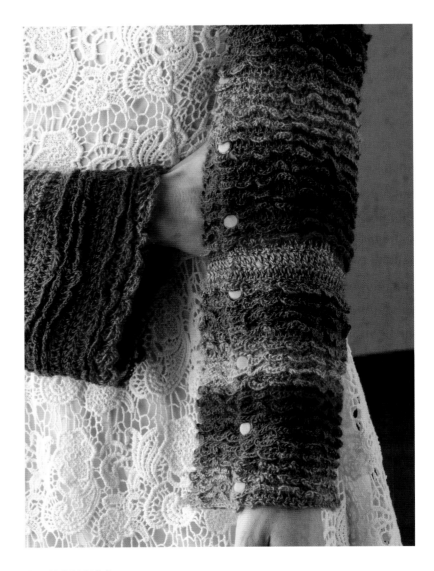

FINISHING

Block garment. Place a marker 12" (30.5 cm) from each end on long edges for sleeves. Place 7 markers evenly spaced to mark where buttons will be sewn. Sew buttons on one side. Use the spaces between double crochet stitches as buttonholes.

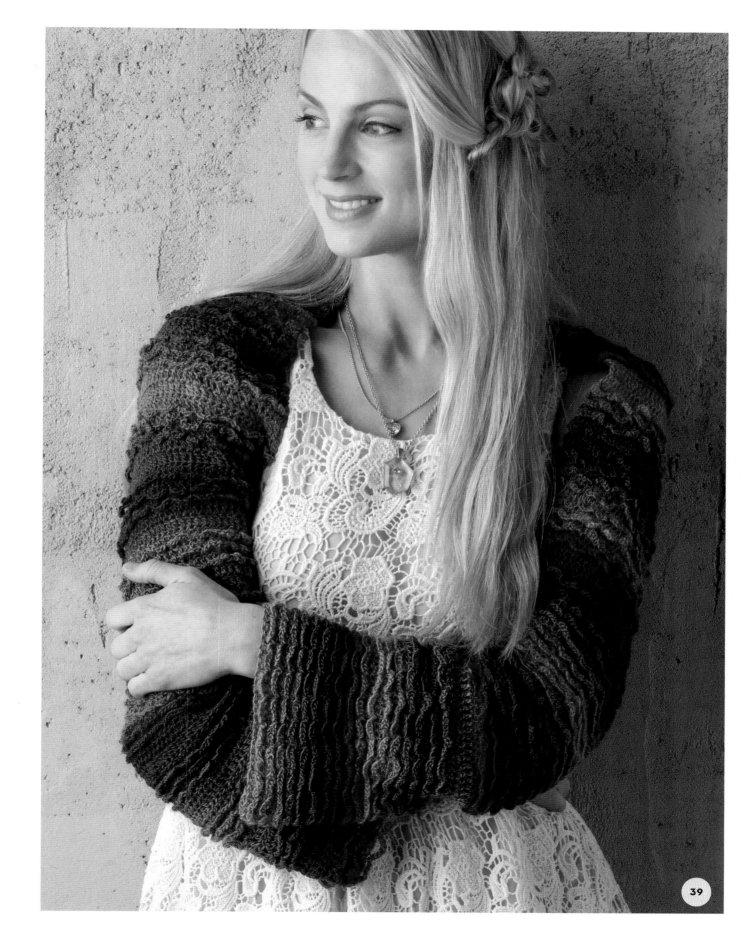

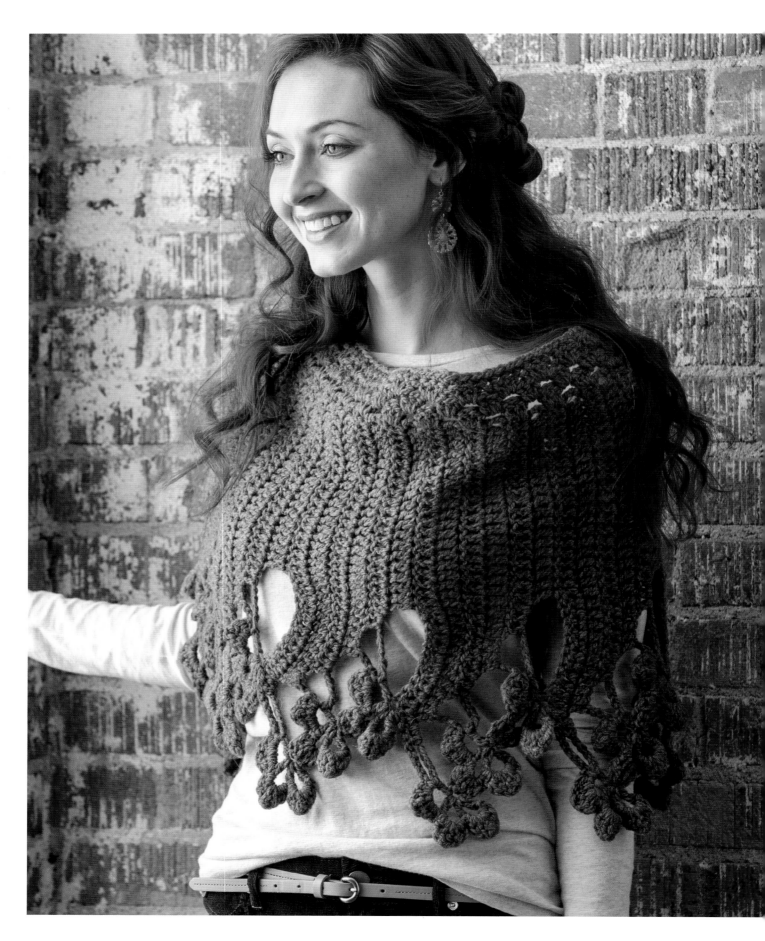

FINISHED SIZE
17" (43 cm) wide and 70" (178 cm) long.

MATERIALS
yarn
Chunky weight (#5 Bulky).

SHOWN HERE: Cascade Ecological Wool (100% natural Peruvian wool; 478 yd/250 g): #8049 Tarnish, 2 skeins.

hook
K/10¾ (7.0 mm). *Adjust hook size if necessary to obtain correct gauge.*

notions
Darning needle; stitch markers.

GAUGE
11 sts and 6 rows dc = 4" (10 cm), after blocking.

SEA *flower*

I fell in love with the pattern on the edge of this design several years ago and have looked forward to using it ever since. It is lacy and flowery, and I like working the soft and feminine stitch pattern with heavier weight yarn. The contrast gives the fabric a good balance between sweetness and modernity. The flower edges flow nicely as you are wearing the piece.

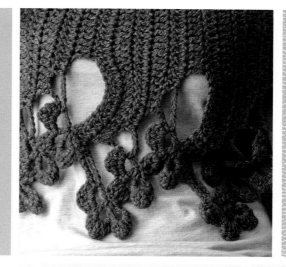

instructions

Ch 23 loosely.

ROW 1: Ch 3 (counts as dc here and throughout), dc in 4th ch from hook, dc in next 19 ch, ch 5, sk next 3 ch, ([dc, ch 3] 3 times, dc) in last ch, turn.

ROW 2: Ch 1, (sc, hdc, dc, tr, dc, hdc, sc) in each of next 3 ch-3 sps, ch 5, sk next 2 ch, dc in each of next 3 ch, dc in each dc across, turn.

ROW 3: Ch 3, dc in each dc across, dc in each of next 3 ch sts, ch 7, ([dc, ch 3] 3 times, dc) in center tr of 2nd petal, turn.

ROW 4: Ch 1, (sc, hdc, dc, tr, dc, hdc, sc) in each of next 3 ch-3 sps, ch 5, sk next 4 ch, dc in each of next 3 ch, dc in each dc across, turn.

ROW 5: Ch 3, dc in each dc across, dc in each of next 3 ch sts, ([dc, ch 3] 3 times, dc) in center tr of 2nd petal, turn.

ROW 6: Rep Row 4.

ROW 7: Ch 3, dc in next 19 dc, ch 7, sk next 11 dc, ([dc, ch 3] 3 times, dc) in next dc, turn.

ROW 8: Rep Row 4.

ROWS 9–102: Rep Rows 3–8 for pattern 15 times, then rep Rows 3–6 once more. Do not turn and do not fasten off.

Note: *For longer shawl, work more reps of Rows 3–8, ending with Rows 3–6.*

EDGING

Turn to work across long edge of shawl.

ROW 1: Sl st in first row-end dc, ch 3, 2 dc in first row-end dc, *sk next row, 3 dc in next row-end dc; rep from * across to last row, sk last row-end dc, dc in corner ch, turn—51 3-dc groups; 154 dc total.

ROW 2: Sl st in sp between first 2 dc, ch 3, 2 dc in the same sp, *3 dc in the sp between next two 3-dc groups; rep from * across to last 3 dc, sk next 2 dc, dc in last dc, turn.

ROW 3: Rep Row 2.

ROW 4: Ch 1, sc in each dc across—154 sc. Fasten off.

FINISHING

Weave in ends. Block garment.

EDGING

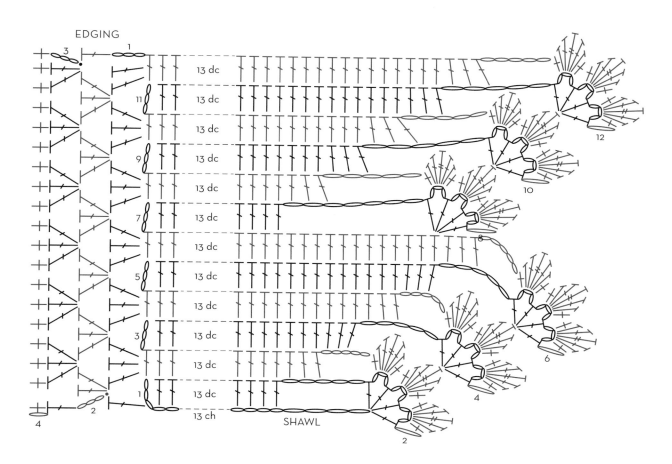

13 dc · 11 · 13 dc · 13 dc · 9 · 13 dc · 13 dc · 7 · 13 dc · 13 dc · 5 · 13 dc · 13 dc · 3 · 13 dc · 13 dc · 1 · 13 dc · 13 ch

SHAWL

3 · 1 · 4 · 2 · 12 · 10 · 8 · 6 · 4 · 2

STITCH KEY

- ⬭ = chain (ch)
- • = slip stitch (sl st)
- ✝ = single crochet (sc)
- ⊤ = half double crochet (hdc)
- ✝ = double crochet (dc)
- ✝ = treble crochet (tr)

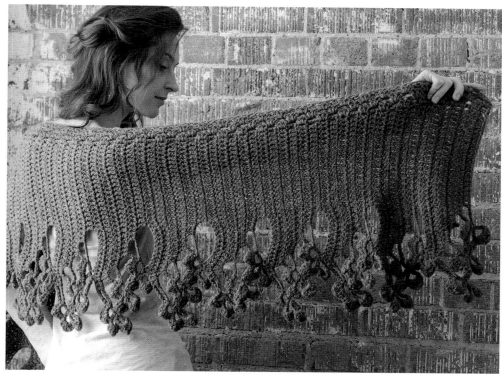

FINISHED SIZE
S (M, L, XL, XXL)

19 (21, 23, 25, 27)" (48.5 [53.5, 58.5, 63.5, 68.5] cm) long as worn.

45 (47½, 50¼, 52, 52)" (114.5 [120.5, 127.5, 132, 132] cm) long from cuff to cuff.

MATERIALS
yarn
DK weight (#3 Light).

SHOWN HERE: Skacel Yarns Savanna Zitron (60% cotton, 20% linen, 20% rayon; 109 yd/50 g): #30 Khaki, 6 (7, 8, 9, 10) balls.

hook
H/8 (5.0 mm) and J/10 (6.0 mm). *Adjust hook size if necessary to obtain correct gauge.*

notions
Darning needle; stitch markers.

GAUGE
16 sts and 7 rows = 4" (10 cm) in puff stitch pattern with smaller hook, after blocking.

pearls

This adorable shrug is created with a puff stitch pattern for the body, a popcorn stitch for the cuffs, and a delicate netting stitch for the collar. The combined effect of these three stitch patterns is an elegant piece that would work well in an office, yet dress up any outfit for an evening on the town.

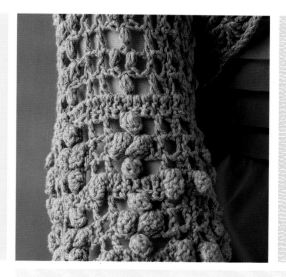

stitch guide

PUFF ST (PF)

Yo, insert hook in next st, yo and draw up a lp, [yo, insert hook in the same st, yo and draw up a lp] twice, yo, draw through 6 lps on hook, yo, draw through the last 2 lps on hook, ch 1 to secure.

POPCORN (POP)

Work 5 dc in the same st, drop lp from hook, insert hook in the top 2 loops of the first dc of 5-dc group (Note: insert hook from front to back when you are working a RS row, and from back to front on a WS row), pick up the dropped lp with hook and pull it through the st, ch 1 to secure.

PUFF STITCH PATTERN (FOR BODY)
(worked over a multiple of 8 sts, plus 3 sts)

SET-UP ROW (WS): Ch 3 (counts as dc), dc in 4th ch from hook and in each ch across, turn.

ROW 1 (RS): Ch 4 (counts as dc, ch 1), sk first 2 dc, dc in next dc, *ch 2, sk next 2 dc, pf in next dc, ch 2, sk next 2 dc, dc in next dc, ch 1, sk next dc, dc in next dc; rep from * across, turn.

ROW 2: Ch 4 (counts as dc and ch 1), sk next ch-1 sp, dc in next dc, *ch 1, pf in 2nd ch of next ch-2 sp, ch 1, pf in first ch of next ch-2 sp, [ch 1, dc in next dc] twice; rep from * across, turn.

ROW 3: Ch 4 (counts as dc and ch 1), sk next ch-1 sp, dc in next dc, *ch 2, sk next ch-1 sp, pf in next ch-1 sp, ch 2, sk next ch-1 sp, dc in next dc, ch 1, sk next ch-1 sp, dc in next dc; rep from * across, turn.

ROWS 4 AND 5: Rep Rows 2 and 3.

ROW 6: Ch 3 (counts as dc), sk first dc, dc in next ch, dc in next dc, *dc in each of next 2 ch, dc in next pf, dc in each of next 2 ch, dc in next dc, dc in next ch, dc in next dc (total 8 dc); rep from * across, turn.

Rep Rows 1–6 for pattern.

POPCORN STITCH PATTERN (FOR CUFF)
(worked over a multiple of 8 sts, plus 3 sts)

ROW 1 (RS): Ch 4 (counts as dc, ch 1), sk first 2 dc, dc in next dc, *ch 2, sk next 2 dc, pop in next dc, ch 2, sk next 2 dc, dc in next dc, ch 1, sk next dc, dc in next dc; rep from * across, turn.

ROW 2 (WS): Ch 4 (counts as dc and ch 1), sk next ch-1 sp, dc in next dc, *ch 1, pop in 2nd ch of next ch-2 sp, ch 1, pop in first ch of next ch-2 sp, [ch 1, dc in next dc] twice; rep from * across, turn.

ROW 3: Ch 4 (counts as dc and ch 1), sk next ch-1 sp, dc in next dc, *ch 2, sk next ch-1 sp, pop in next ch-1 sp, ch 2, sk next ch-1 sp, dc in next dc, ch 1, sk next ch-1 sp, dc in next dc; rep from * across, turn.

ROW 4: Ch 3 (counts as dc), pop in next ch, dc in next dc, *dc in each of next 2 ch, dc in next pop, dc in each of next 2 ch, dc in next dc, pop in next ch, dc in next dc; rep from * across, turn.

Rep Rows 1–4 for pattern.

NETTING STITCH PATTERN (FOR BODY EDGING/COLLAR)

RND 1: Sc in sp below and replace marker to show beg of rnd, *[ch 1, tr] 3 times in next sc, ch 1, sc in next ch-7 sp**, ch 7, sc in next ch-7 sp; rep from * around, ending last rep at **, ch 3, tr in sc at beg of rnd instead of last ch-7 sp.

RND 2: Sc in sp below and replace marker to show beg of rnd, *ch 7, sc in 2nd tr of next shell**, ch 7, sc into next ch-7 sp; rep from * around, ending last rep at **, ch 3, tr in sc at beg of rnd.

Rep Rnds 1 and 2 for pattern.

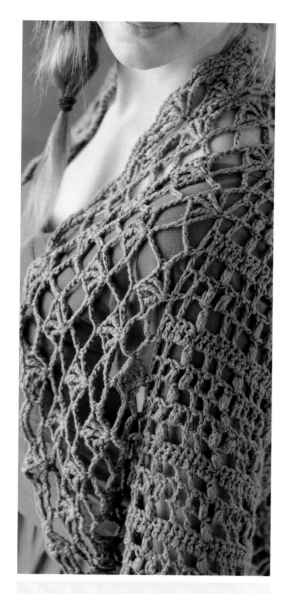

instructions

BODY

With larger hook, ch 51 (59, 67, 75, 83).

Note: *Second cuff will be worked into foundation ch later.*

SET-UP ROW: Change to smaller hook and work puff stitch pattern Set-up Row (see Stitch Guide)—51 (59, 67, 75, 83) sts.

ROWS 1–6: Work puff stitch pattern Rows 1–6.

ROWS 7–10: Work puff stitch pattern Rows 3–6. Place marker in the top of the first dc and last dc of Row 10 to mark underarm.

ROWS 11–26: Rep Rows 1–10, but don't place marker. Then work Rows 1–6 once.

ROWS 27–38 (42, 46, 50, 50): Work puff stitch pattern Rows 1 and 2 (5 [7, 9, 11, 11] times), then work Row 1 once, then work Row 6 once.

ROWS 39–64 (43–68, 47–72, 51–76, 51–76): Rep Rows 1–10 without placing marker, and then rep Rows 1–5. Place marker in the top and last dc of the first dc of Row 53 (57, 61, 65, 65) to mark underarm. Then rep Rows 6–10 without placing marker, and then rep Rows 1–6. Do not fasten off.

STITCH KEY

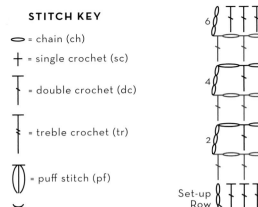

- ⬭ = chain (ch)
- ✚ = single crochet (sc)
- ┰ = double crochet (dc)
- ╪ = treble crochet (tr)
- ⬮ = puff stitch (pf)
- ⬮ = popcorn (pop)

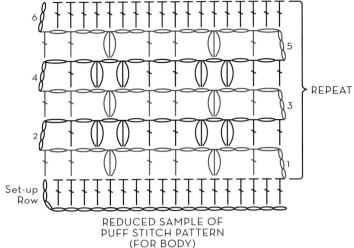

REDUCED SAMPLE OF
PUFF STITCH PATTERN
(FOR BODY)

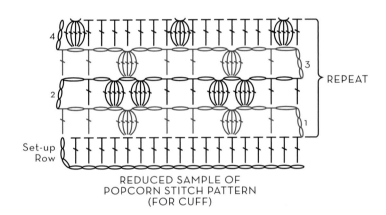

REDUCED SAMPLE OF
POPCORN STITCH PATTERN
(FOR CUFF)

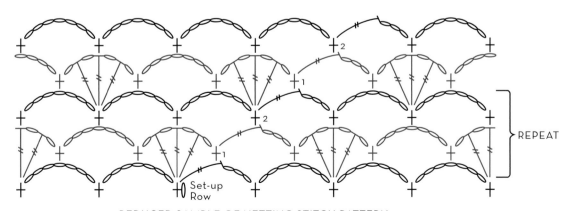

REDUCED SAMPLE OF NETTING STITCH PATTERN
(FOR BODY EDGING/COLLAR)

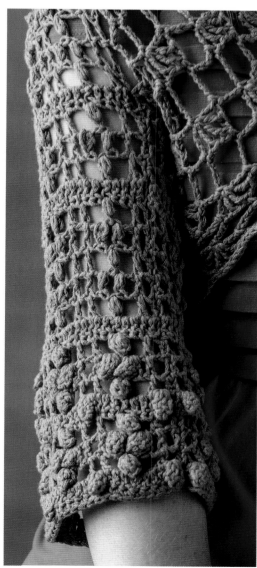

FIRST CUFF

Cont working from body as foll:

Work popcorn stitch pattern (see Stitch Guide) Rows 1–4 twice.

LAST ROW: Ch 1, sc in each st across. Fasten off.

SECOND CUFF

With RS of body facing, working across opposite side of foundation ch, join yarn in first ch, ch 4 (counts as dc and ch 1), sk next 2 ch, dc in next ch, *ch 2, sk next 2 ch, pop in next ch, ch 2, sk next 2 ch, dc in next ch, ch 1, sk next dc, dc in next ch; rep from * across, turn.

Work popcorn stitch pattern Rows 2–4, then rep Rows 1–4 once. Fasten off.

Sew the sleeve seams from the cuff edges to the underarm markers. Do not take off markers yet (**figure 1**).

There are still 4 markers on the body.

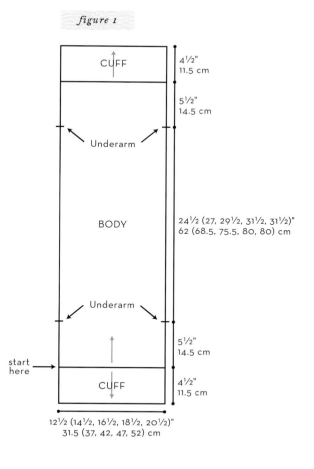

figure 1

CUFF — 4½" 11.5 cm

5½" 14.5 cm

Underarm

BODY — 24½ (27, 29½, 31½, 31½)" 62 (68.5, 75.5, 80, 80) cm

Underarm

5½" 14.5 cm

start here

CUFF — 4½" 11.5 cm

12½ (14½, 16½, 18½, 20½)" 31.5 (37, 42, 47, 52) cm

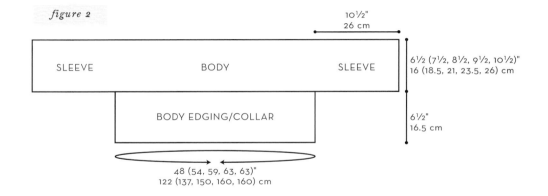

figure 2

SLEEVE BODY SLEEVE

10½"
26 cm

6½ (7½, 8½, 9½, 10½)"
16 (18.5, 21, 23.5, 26) cm

BODY EDGING/COLLAR

6½"
16.5 cm

48 (54, 59, 63, 63)"
122 (137, 150, 160, 160) cm

BODY EDGING/COLLAR

You are working the body opening edging now, which will also become the collar (**figure 2**). Lay down the shrug with the body opening up and the RS facing you. Work as foll:

SET-UP RND: Starting at the right, join yarn with a sl st in top of first marked dc where the underarm was marked, ch 1, sc in same place. (Note: This first sc should be worked in the side of the top of a dc, not in the dc post. There are 43 [47, 51, 55, 55] dc posts on this side until next marker.) *Ch 7, sk next 2 dc posts, sc in top of next dc (not in or around the post); rep from * until one dc post is left before next marker, ch 7, sk next marker, sc in following marker. (Note: These 2 markers are next to each other. Last sc is worked on the other side of the body opening. At this point, you have worked 22 [24, 26, 28, 28] sets of ch-7.) Rep from * to * once, ch 3, tr in first sc at beg of rnd—44 (48, 52, 56, 56) ch-7 sps.

RNDS 1–8: Work netting stitch pattern Rows 1 and 2 (4 times).

RND 9: Work netting stitch pattern Row 1, but end with ch 7, sl st in first sc.

RND 10: *[Sc in next ch-1 sp, sc in next tr] 3 times, sc in next ch-1 sp, 7 sc in next ch-7 sp; rep from * around, join with a sl st in first sc.

Fasten off. Remove all markers.

FINISHING

Weave in ends. Block garment.

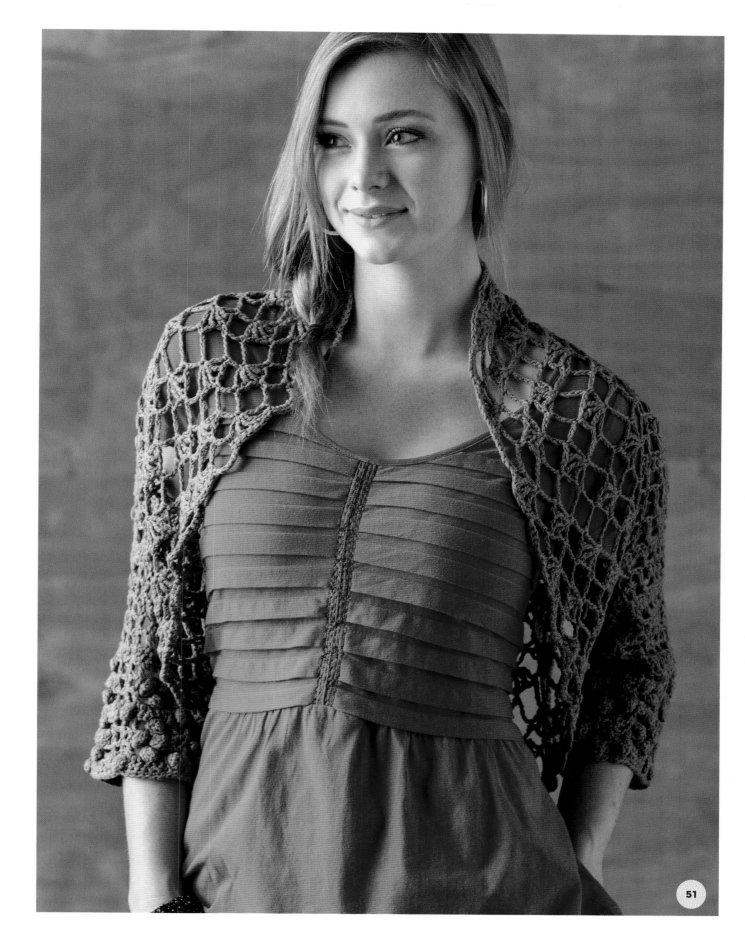

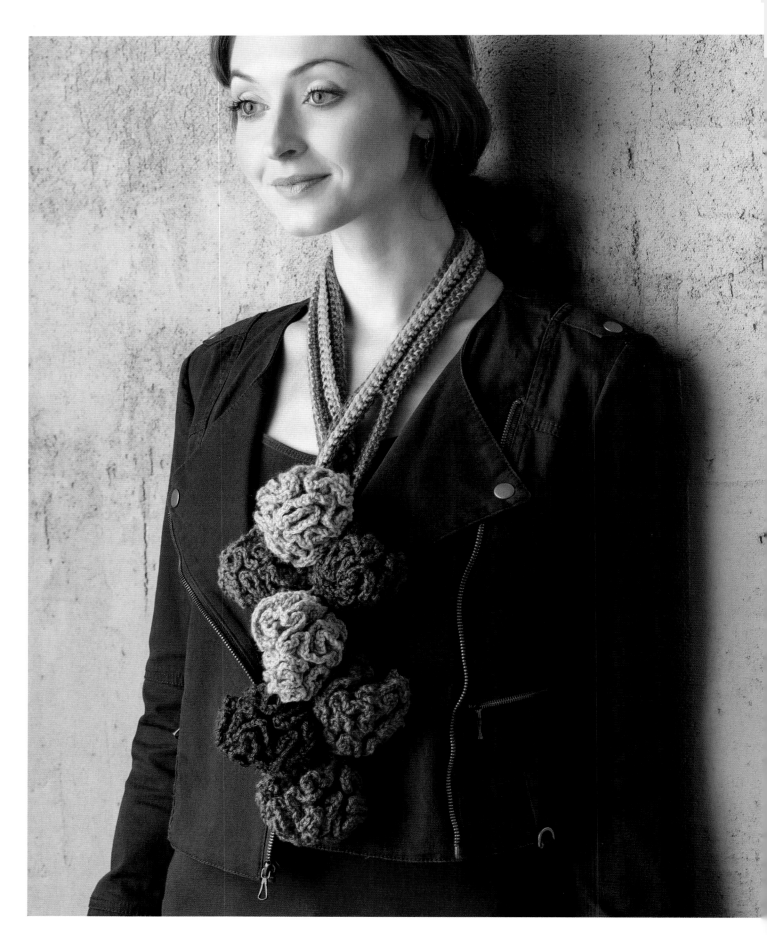

FINISHED SIZE
About 38" (96.5 cm) long;
Each Flower Ball = about
2½" (6.5 cm) in diameter.

MATERIALS

yarn

DK weight (#3 Light).

SHOWN HERE: Universal Yarn
Eden Silk (75% merino wool,
25% silk; 153 yd/50 g): #10 Coal
(A), #17 Oatmeal (B), and #9
Bark (C), 1 ball each.

hook

H/8 (5.0 mm). *Adjust hook size
if necessary to obtain correct
gauge.*

notions

Darning needle; stitch markers.

GAUGE

15 sts = 4" (10 cm) in single
crochet, after blocking.

CORAL *bouquet*

Several years ago I joined a group that was making
a crocheted coral reef to raise awareness about
our overuse of plastic and its effect on ocean life.
While working on it, I learned about a simple method
of continuously increasing two to three stitches in
each stitch to make an interesting shape. I liked this
technique so much I kept a sample, thinking I could use
it for tying and decorating gift packages. Ultimately it
became my inspiration for this scarf.

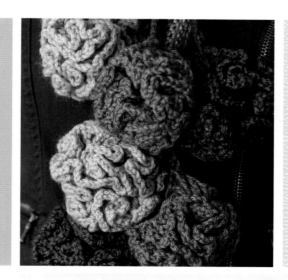

FLOWER BALL PATTERN

BASE RING: Ch 10, sl st in first ch to form a ring.

RND 1: Ch 3 (counts as dc), 24 dc in ring, place marker in last dc, then work 25 more dc in ring, join with a sl st in top of beg ch-3—50 dc.

RND 2: Ch 6 (counts as tr, ch 2), [tr, ch 2] twice in first st, [tr, ch 2] 3 times in each dc to marked dc, remove marker and place it in last ch-2 sp, [tr, ch 2] 3 times in each of next 25 dc, insert hook in top of first tr and then into ch-2 sp with a marker (on opposite side of rnd), yo, draw yarn through all sts and lp on hook forming a sl st.

instructions

Make first Flower Ball Strip (see below), then make 2nd Flower Ball Strip and attach it to first Strip (see below). Then make 3rd Flower Ball Strip and attach it, etc. A total of 7 Flower Ball Strips are made and attached. Work each Flower Ball Strip foll Assembly Diagram (page 56) for placement.

FIRST FLOWER BALL STRIP (A-1)

With A, make Flower Ball (see Stitch Guide), do not remove marker and do not fasten off.

Ch 100, turn, ch 3 (counts as dc), place marker in top of ch 3, dc in 5th ch from hook, dc in each of next 88 ch, hdc in each of next 2 ch, sc in each of next 8 ch, sl st in same sp as sl st at the end of Flower Ball, ch 1 to secure st—90 dc; 2 hdc; 8 sc. Fasten off.

SECOND FLOWER BALL STRIP (B-1)

With B, make Flower Ball, do not remove marker and do not fasten off.

ROW 1: Ch 5, lay down Flower Ball Strip A-1 with Flower Ball on left and Strip on right, sc in front loop only in marked st on Flower Ball Strip A-1 and do not remove marker, sc in front loop only of each of next 89 dc on Flower Ball Strip A-1 (90 sc), turn, leaving rem sts unworked.

ROW 2: Ch 1, sc in each sc across, sc in each of next 5 ch, sl st in same sp as sl st at the end of Flower Ball B-1, ch 1 to secure st. Fasten off.

THIRD FLOWER BALL STRIP (C-1)

With C, make Flower Ball, do not remove marker and do not fasten off.

ROW 1: Ch 10, lay down Flower Ball Strips with Flower Ball A-1 on left, sc in back loop only in marked st on Flower Ball Strip A-1 and remove marker, sc in back loop only of each of next 4 sc, ch 15, sk next 15 sc, sc in back loop only of each of next 70 sc on Flower Ball Strip B-1, turn, leaving rem sts unworked.

ROW 2: Ch 1, sc in first sc, place marker, sc in each of next 69 sc, sc in each of next 15 ch, sc in each of next 5 sc, sc in each of next 10 ch, sl st in same sp as sl st at the end of Flower Ball C-1, ch 1 to secure st. Fasten off.

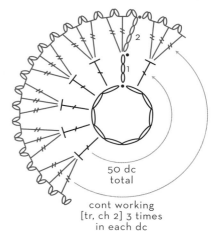

STITCH KEY

⬭ = chain (ch)

• = slip stitch (sl st)

╈ = double crochet (dc)

╪ = treble crochet (tr)

50 dc
total

cont working
[tr, ch 2] 3 times
in each dc

FLOWER BALL

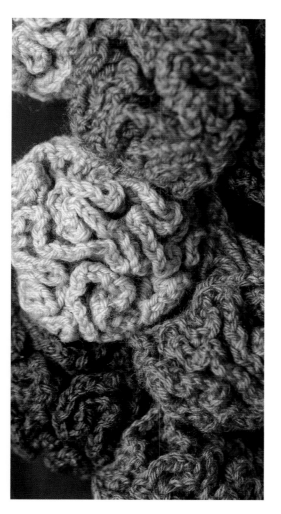

FOURTH FLOWER BALL STRIP (B-2)

With B, make Flower Ball, do not remove marker and do not fasten off.

ROW 1: Ch 3, lay down Flower Ball Strips with Flower Ball C-1 on left, sc in marked st on Flower Ball Strip C-1 and remove marker, sc in each of next 89 sc on Flower Ball Strip C-1 (90 sc), turn, leaving rem sts unworked.

ROW 2: Ch 1, sc in first sc across, place marker, sc in each of next 89 sc, sc in each of next 3 ch, sl st in same sp as sl st at the end of Flower Ball B-2, ch 1 to secure st. Fasten off.

FIFTH FLOWER BALL STRIP (A-2)

With A, make Flower Ball, do not remove marker and do not fasten off.

ROW 1: Ch 15, lay down Flower Ball Strips with Flower Ball B-2 on left, sc in back loop only of marked st on Flower Ball Strip B-2 and remove marker, sc in back loop only of each of next 89 sc on Flower Ball Strip B-2 (90 sc), place marker on front loop of last st worked on Flower Ball Strip B-2, turn, leaving rem sts unworked.

ROW 2: Ch 1, sc in each sc across, then sc in each of 15 ch, sl st in same sp as sl st at the end of Flower Ball A-2, ch 1 to secure st. Fasten off.

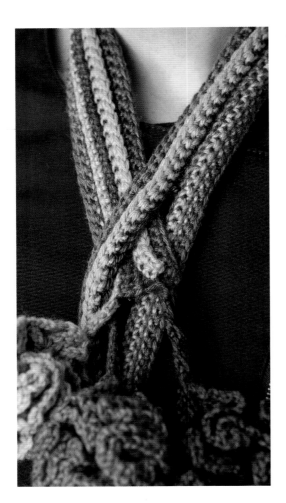

SIXTH FLOWER BALL STRIP (C-2)

With C, make Flower Ball, do not remove marker and do not fasten off.

ROW 1: Ch 6, lay down Flower Ball Strips with Flower Ball B-2 on right, sc in front loop only of marked st on Flower Ball Strip B-2 and remove marker, sc in each of next 89 sc on Flower Ball Strip B-2 (90 sc), turn, leaving rem sts unworked.

ROW 2: Ch 1, sc in each sc across, sc in each of next 6 ch, sl st in same sp as sl st at the end of Flower Ball C-2, ch 1 to secure st. Fasten off.

SEVENTH FLOWER BALL STRIP (C-3)

With C, make Flower Ball, do not remove marker and do not fasten off.

ROW 1: Ch 20, lay down Flower Ball Strips with Flower Ball A-1 on left and base chain up, sc through in first base chain on Flower Ball Strip A-1, sc in each of next 89 base chains on Flower Ball Strip A-1, turn, leaving rem sts unworked.

ROW 2: Ch 1, sc in each sc across, sc in each of next 20 ch, sl st in same sp as sl st at the end of Flower Ball C-3, ch 1 to secure st. Fasten off.

FINISHING

Weave in ends.

ASSEMBLY DIAGRAM

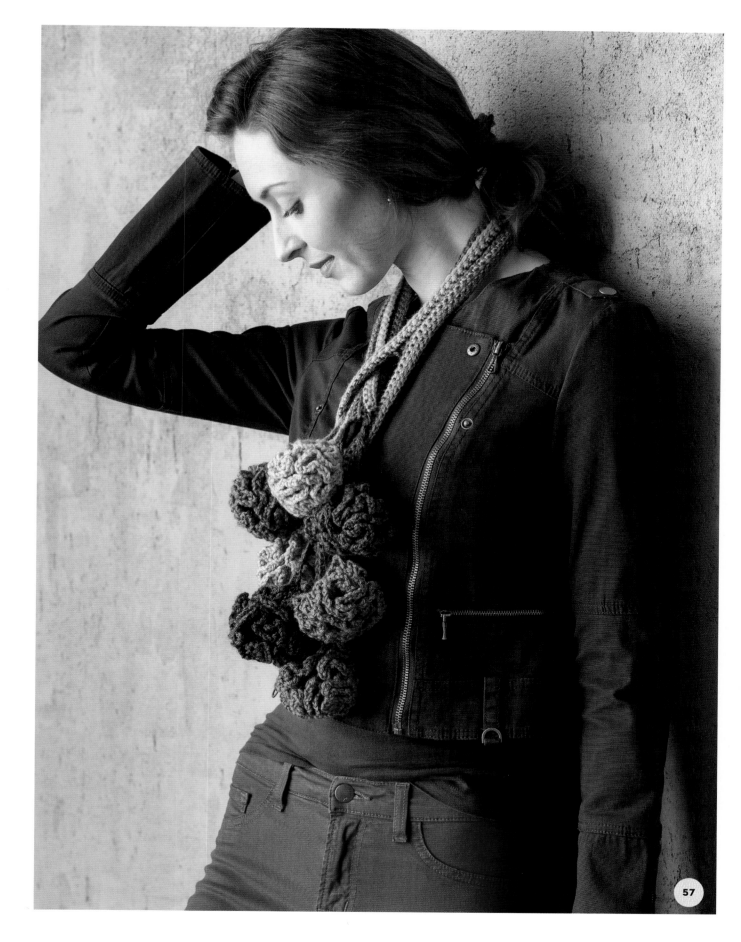

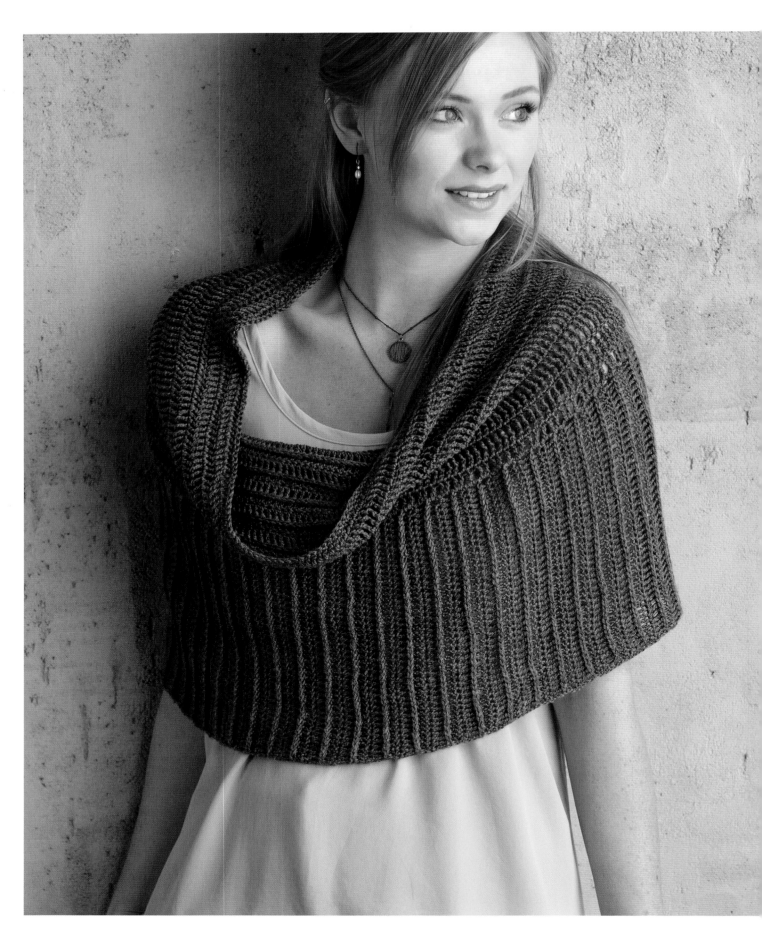

FINISHED SIZE
S–M (M–L, L–XL)

42½ (48, 53½)" (108 [122, 136] cm) in circumference at bottom.

33½ (38, 40½)" (85 [96.5, 103] cm) in circumference at top.

17½ (19½, 21¼)" (44.5 [49.5, 54] cm) long.

MATERIALS

yarn

Fingering weight (#1 Super Fine).

SHOWN HERE: Cascade Heritage Silk (85% merino superwash wool, 15% mulberry silk; 437 yd/100 g): #5631 Dark Gray, 2 (4, 5) skeins.

hook

G/6 (4.0 mm) and H/8 (5.0 mm). *Adjust hook size if necessary to obtain correct gauge.*

notions

Darning needle.

GAUGE
About 19 sts and 9 rows = 4" (10 cm) in body stitch pattern with smaller hook, after blocking.

SHALE *tiers*

I wanted this design to be simple: elegant and easy, yet sophisticated and textured. I used the same stitch throughout, a two-row repeat, making it easy to work up. The collar and wrap are worked in different directions to keep the shape elegant, clean, and nicely draped over your shoulders, showing off the linear look of the stitches.

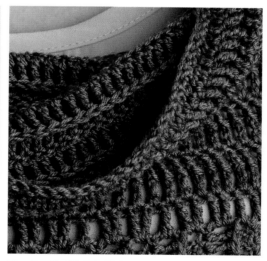

stitch guide

FRONT POST TREBLE CROCHET (FPTR)

Yo (twice), insert hook from front to back to front again around the post of next st, yo, draw yarn through st, yo, draw yarn through 2 lps on hook, yo, draw yarn through 2 lps on hook (2 lps on hook), yo, draw yarn through 2 lps on hook.

BODY STITCH PATTERN
(worked in rows over any number of sts)

ROW 1 (RS): Ch 4 (counts as tr), tr in each st across, turn.

ROW 2 (WS): Ch 3 (counts as dc), Fptr (see Stitch Guide) in each st across until last st, dc in last st, turn.

Rep Rows 1 and 2 for pattern.

BODY STITCH PATTERN
(worked in rnds over any number of sts)

RND 1 (WS): Ch 4 (counts as tr), tr in each st around, sl st in top of beg ch-4, turn.

RND 2 (RS): Insert hook from front to back around the vertical post of the first st as for a Front post st, yo and draw yarn through post as for a sl st, ch 4 (counts as beg Fptr), Fptr in each st across, sl st in top of beg ch-4, turn.

Rep Rnds 1 and 2 for pattern.

instructions

BELOW SHOULDER LINE (WRAP)

With larger hook, ch 42 (46, 51). Note: For a longer body, just add more chains at this point. Any numbers of stitches can be worked for this stitch pattern.

Change to smaller hook, work Set-up Row (counts as Row 1) as foll:

SET-UP-ROW: Ch 4 (counts as tr), tr in 5th ch from hook, tr in each ch across, turn—43 (47, 52) tr.

Work in body stitch pattern—worked in rows (see Stitch Guide) for 96 (108, 120) rows (including Set-up Row) as foll:

Work body stitch pattern Row 2 (WS). Then rep body stitch pattern Rows 1 and 2 (47 [53, 59] times).

Note: Work will be about 42½ (48, 53½)" (108 [122, 136] cm) from foundation ch after blocking. If you want to make sure the length is right, block the fabric at this point.

Fasten off, leaving a 15" (38 cm) sewing length. With sewing length, matching sts, sew last row to foundation ch to form a tube.

ABOVE SHOULDER LINE (COLLAR)

Note: The textured side of the stitch pattern will be on the inside of the fabric, so that the textured side will show on the outside after folding the collar down.

Lay down the tube that you just completed, and with the RS facing you, join yarn with a sl st in around the post of any row-end tr or dc on the top edge, work Set-up Rnd as foll:

SIZES S–M AND M–L ONLY

SET-UP RND (RS): Ch 4 (counts as tr), tr in the same row-end st, 2 tr in next row-end st, tr in next row-end st, *[2 tr in next row-end st] twice, tr in next row-end st; rep from * around, sl st in top of beg ch-4, turn—160 (180) tr.

STITCH KEY

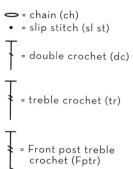

- ⬯ = chain (ch)
- • = slip stitch (sl st)
- ⊤ = double crochet (dc)
- ⊤ = treble crochet (tr)
- ⊤ = Front post treble crochet (Fptr)

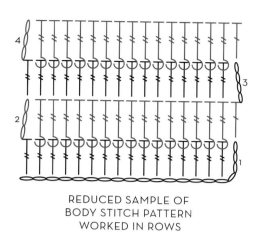

REDUCED SAMPLE OF
BODY STITCH PATTERN
WORKED IN ROWS

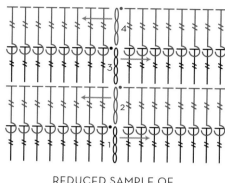

REDUCED SAMPLE OF
BODY STITCH PATTERN
WORKED IN RNDS

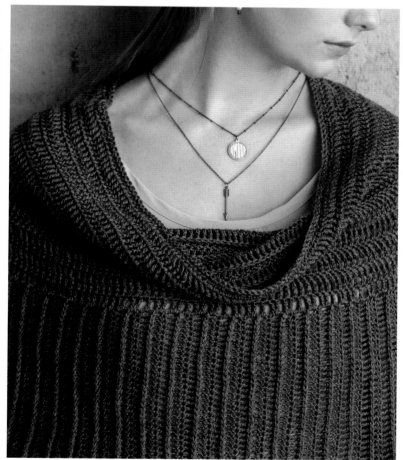

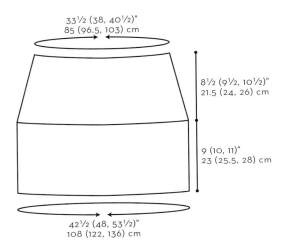

33½ (38, 40½)"
85 (96.5, 103) cm

8½ (9½, 10½)"
21.5 (24, 26) cm

9 (10, 11)"
23 (25.5, 28) cm

42½ (48, 53½)"
108 (122, 136) cm

SIZE L–XL ONLY

SET-UP RND (RS): Ch 4 (counts as tr), tr in the same row-end st, [2 tr in next row-end st, tr in next row-end st] twice, *2 tr in next row-end st, [2 tr in next row-end st, tr in next row-end st] twice; rep from * around, sl st in top of beg ch-4, turn—192 tr.

Then work body stitch pattern in rnds as foll:

Work Rnds 1 and 2 (9 [10, 11] times), then rep Rnd 1 once more. Fasten off.

FINISHING

Weave in ends. Block garment.

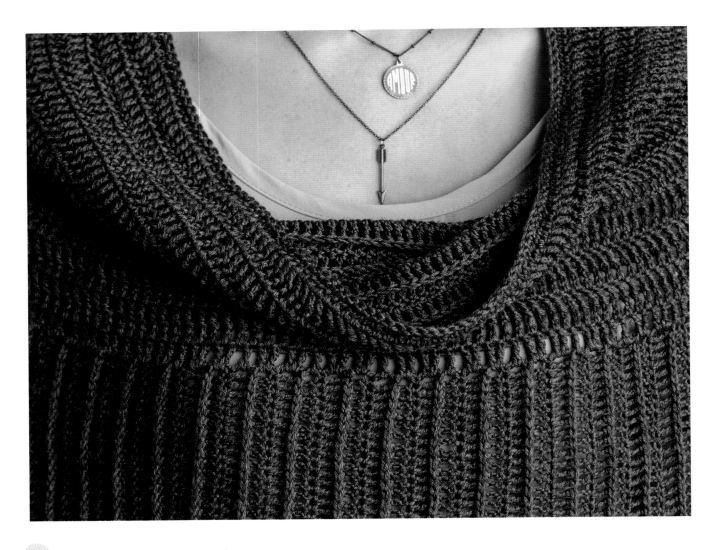

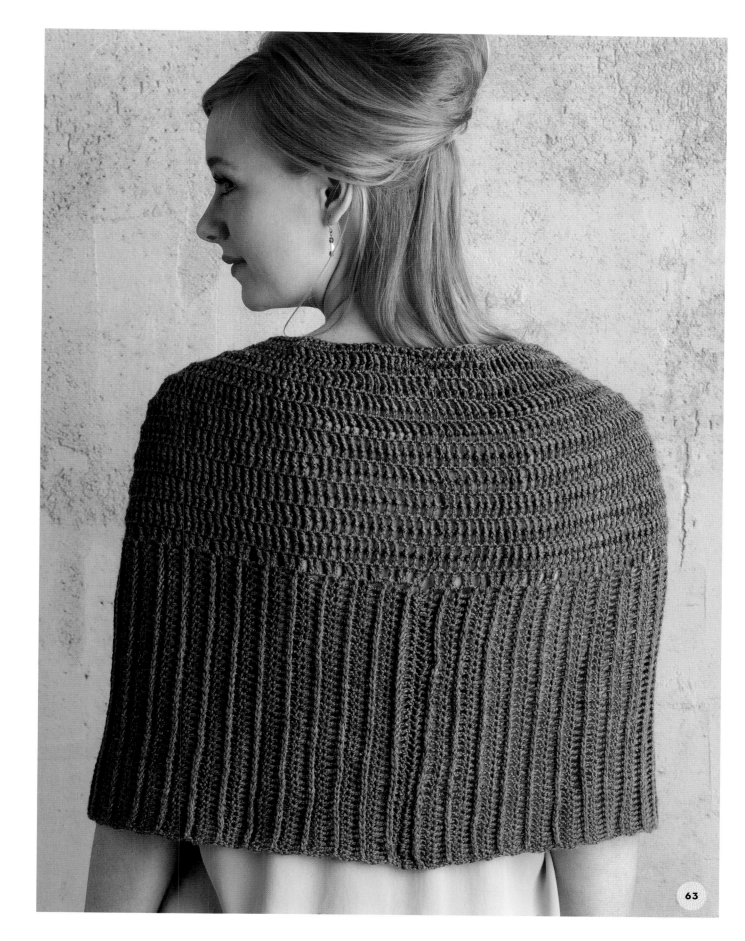

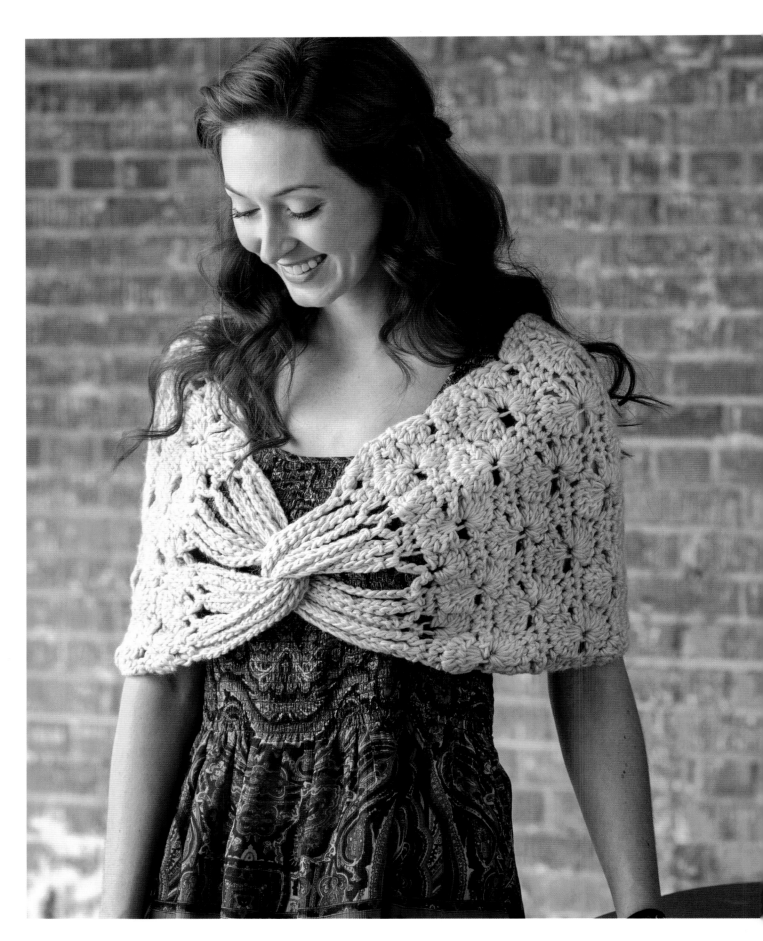

FINISHED SIZE
S (M-L, XL-XXL)

14 (14, 17¼)" (35.5 [35.5, 44] cm)
long when worn.

33 (39, 45)" (84 [99, 114.5] cm)
in circumference.

MATERIALS
yarn
Worsted weight (#4 Medium).

SHOWN HERE: Cascade Eco
Duo (70% baby alpaca, 30%
merino wool; 197 yd/100 g):
#1705 Vanilla, 3 (4, 6) skeins.

hook
M/13 (9.0 mm). *Adjust hook
size if necessary to obtain
correct gauge.*

notions
Darning needle; stitch markers;
waste yarn.

GAUGE
10 sts and 4 rows (1 repeat of
wheel stitch pattern) = 3⅜"
(8.5 cm) by 3" (7.5 cm) in wheel
stitch pattern with 2 strands
of yarn held together, after
blocking.

SAND *dollar*

Alpaca-blend and single-spun yarns are two of my favorites to work with in crochet. Combine the two and a beautiful fabric results. So, I chose my favorite yarn for my personal crochet projects, Eco Duo, to work with in this design. To make the wheel stitch pattern sturdier, I used two strands held together and kept the overall design simple so the stitches become the focus. The texture of the center crossing pieces serves as the perfect complement to the warm, cozy look of the wrap.

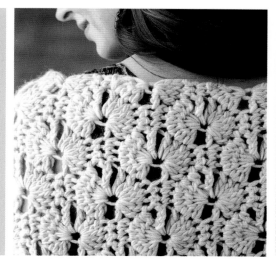

CLUSTER 7 (CL7)
[Yo, insert hook into next st, yo, draw up a lp, yo, draw through 2 lps on hook] 7 times, yo, draw through all 8 lps on hook.

CLUSTER 4 (CL4)
[Yo insert hook into next st, yo, draw up a lp, yo, draw through 2 lps on hook] 4 times, yo, draw through all 5 lps on hook.

CLUSTER 3 (CL3)
[Yo insert hook into next st, yo, draw up a lp, yo, draw through 2 lps on hook] 3 times, yo, draw through all 4 lps on hook.

WHEEL STITCH PATTERN
(multiple of 10 sts, plus 1 st)

ROW 1 (RS): Ch 3 (counts as dc), 3 dc in 4th ch from hook, *sk next 3 ch, sc in next 3 ch, sk next 3 ch**, 7 dc in next ch; rep from * across, ending last rep at **, 4 dc in last ch, turn.

ROW 2 (WS): Ch 1, sc in first 2 dc *ch 3, cl7 over next 7 sts (see Stitch Guide), ch 3 **, sc in next 3 dc; rep from * across, ending last rep at **, sc in last 2 dc, turn.

ROW 3: Ch 1, sc in first 2 sc, *7 dc in 3rd ch of next ch-3 sp, sk next cl7, sk next ch 3, sc in next 3 sc; rep from * across, ending last rep at **, ending last rep at **, sc in last 2 sc, turn.

ROW 4: Ch 2, sk in first sc, cl3 over next 3 sts (see Stitch Guide), *ch 3, sc in next 3 dc, ch 3**, cl7 over next 7 sts; rep from * across, ending last rep at **, cl4 over last 4 sts (see Stitch Guide), ch 1, turn.

ROW 5: Ch 3 more (counts as dc), 3 dc in 4th ch from hook, *sk next 3 ch, sc in next 3 sc**, 7 dc in 3rd ch of next ch-3 sp; rep from * across, ending last rep at **, 4 dc in 3rd ch of last ch-3 sp, turn.

Rep Rows 2–5 for pattern.

instructions

Note: *All stitches are worked with 2 strands of yarn held tog.*

MAIN BODY
With 2 strands of yarn held tog, ch 41 (41, 51).

Work wheel stitch pattern Row 1 (see Stitch Guide), then place markers on the foundation ch as foll:

Place marker on the first ch and last ch (2 markers), on each ch-3 sp (8 [8, 10] markers), and on the center ch of the 3 chs that the groups of 3 sc were worked into (4 [4, 5] markers). There are a total of 14 (14, 17) markers on foundation chs that will be used when you work the front-closure chs.

Start working wheel stitch pattern as foll:

Work Rows 2–5 (8 [10, 12]) times, then work wheel stitch pattern Rows 2–4 once more. Do not fasten off.

Place marker on the last row as foll:

Place markers on the top of the first st and on last st (2 markers), in each ch-3 sp (8 [8, 10] markers), and on the center sc of each group of 3 scs (4 [4, 5] markers).

There are 14 (14, 17) markers on the last row.

FRONT CHAIN CLOSURE
With yarn still held double, ch 1, sc in first marked place on right (stitch A on page 68).

Remove marker, ch 25, sc in the first marked place on the left (N [N, Q] on page 68).

Remove marker, ch 25, sc in the first marked place on the right (B on page 68).

Remove marker, ch 25, sc in the first marked place on the left (M [M, P] on page 68).

Remove marker, ch 25, sc in the first marked place on the right (C on page 68).

Cont in this manner until there are no more markers on the row. Fasten off.

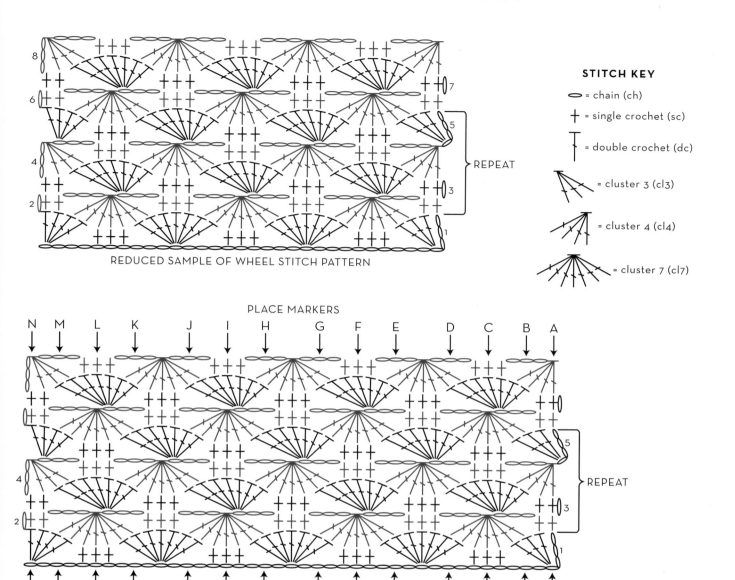

REDUCED SAMPLE OF WHEEL STITCH PATTERN

STITCH KEY

⬭ = chain (ch)

+ = single crochet (sc)

T = double crochet (dc)

= cluster 3 (cl3)

= cluster 4 (cl4)

= cluster 7 (cl7)

REPEAT

MARKER PLACEMENT FOR SIZES S AND M-L

Gather the center of all the ch-25 lps tog and tie them into a bundle with waste yarn.

On the edge of foundation chs:

Lay down the body that you just completed and fold in half with RS facing out, with the edge with the foundation ch on top and the other edge with the bundle of ch lps tied tog lying below the edge with the foundation ch.

Insert hook in the first marked foundation ch on the right, ch 1, sc in the same ch, remove the marker, ch 25, then pass the ch through the center lp where the bundle of chs on the other end are tied together, from back to front, sc in the first marked place on the left.

continue chains

CHAIN ASSEMBLY SIZES S AND M-L

continue chains

CHAIN ASSEMBLY SIZES XL-XXL

Remove marker, ch 25, pass the ch back through the center of the bundle of ch lps, sc in the first marked place on the right.

Remove marker, ch 25, pass the ch back through the center of the bundle of ch lps, from back to front, sc in the first marked place on the left.

Remove marker, ch 25, pass the ch back through the center of the bundle of ch lps, sc in the first marked place on the right.

Cont in this manner until there are no more markers on the row. Fasten off.

FINISHING

Remove waste yarn from bundle of ch-25 lps. Weave in ends. Block garment.

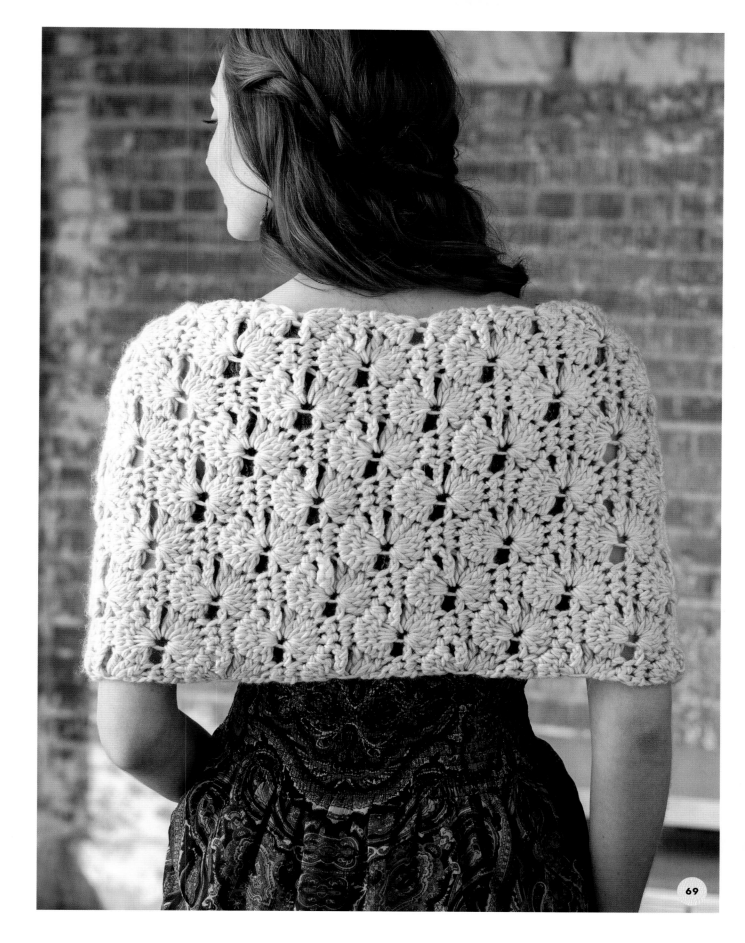

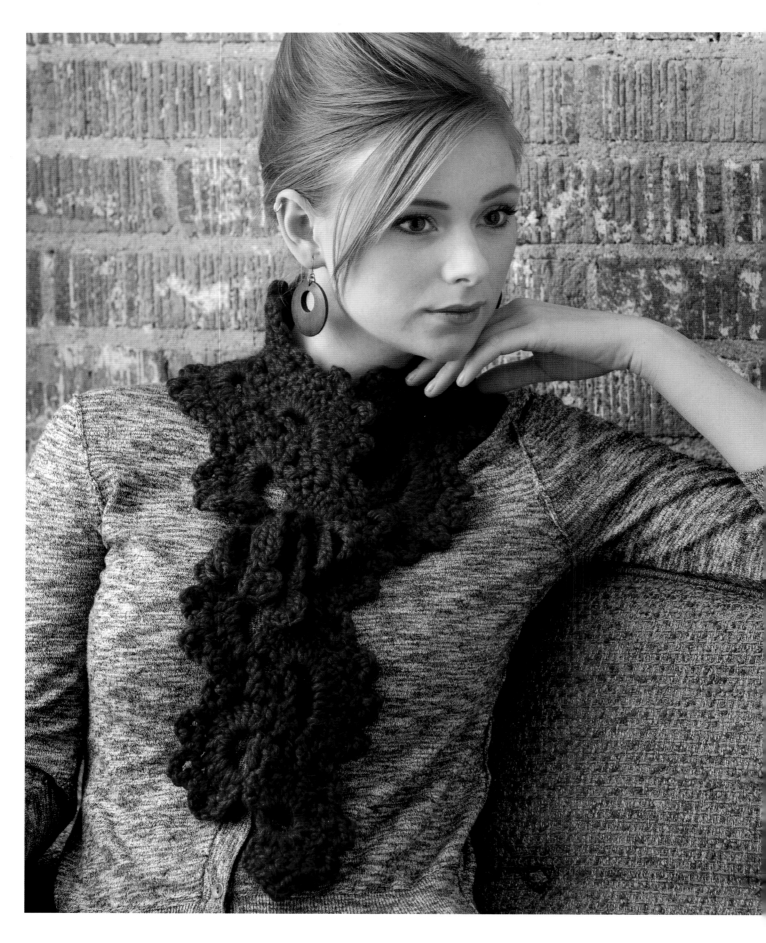

WATER *lily*

This one-skein design is a quick project using chunky-weight yarn with a large hook.

Water Lily is made with many flower motifs; each one is connected to the last stitch of the previous motif. To wear this neck warmer, pass the cord through the center of the motifs. The curvy shape of the motifs makes a pretty decoration around the neckline.

instructions

FIRST MOTIF

Ch 6, sl st in first ch to form a ring.

ROW 1: Ch 3 (counts as dc), 13 dc in ring, turn—14 dc.

ROW 2: Ch 1, sc in each of first 2 dc, [ch 4, sc in each of next 2 dc] 6 times, place marker in last ch-4 lp, turn—6 ch-4 lps. Do not fasten off.

SECOND MOTIF

Ch 6, sl st into marked ch-4 lp of first motif, remove marker and turn.

ROW 1: Ch 3 (counts as dc), 13 dc in ch-6 sp, turn—14 dc.

ROW 2: Ch 1, sc in each of first 2 dc, [ch 4, sc in each of next 2 dc] 6 times, place marker in last ch-4 lp, sl st into next free ch-4 sp on first motif, turn—6 ch-4 lps. Do not fasten off.

THIRD MOTIF

Ch 6, sl st into marked ch-4 lp on second motif, remove marker, turn.

ROW 1: Ch 3 (counts as dc), 13 dc in ch-6 sp, sl st in next free ch-4 lp of previous motif, turn—14 dc.

ROW 2: Ch 1, sc in each of first 2 dc, [ch 4, sc in each of next 2 dc] 6 times, place marker in last ch-4 lp, sl st in next free ch-4 lp of previous motif, turn—6 ch-4 lps. Do not fasten off.

FOURTH THROUGH FOURTEENTH MOTIFS

Rep third motif until there are 14 motifs total.

Do not remove the marker on last ch-4 lp of last motif (14th motif). Place another marker in the next ch-4 lp on 13th motif. Cords will be worked on those ch-4 lps in the next step.

Fasten off.

FIRST CORD

Join yarn in either marked ch-4 lp, [ch 10, place marker in last ch] twice, ch 12, [2 dc, ch 2, sl st] in 3rd ch from hook, ch 9, [sk next 9 ch, sl st in next marked ch] twice, ch 9, sl st in ch-4 lp of the motif where cord was started. Fasten off.

SECOND CORD

Work same as first cord, starting in other marked ch-4 lp.

FINISHING

Remove all markers. Weave in ends. Block scarf.

STITCH KEY

⬭ = chain (ch)

• = slip stitch (sl st)

╀ = single crochet (sc)

╫ = double crochet (dc)

✳ = marker

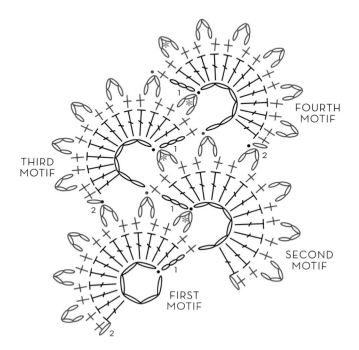

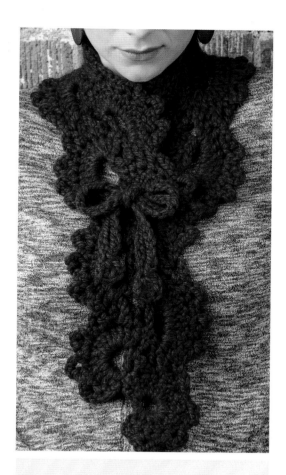

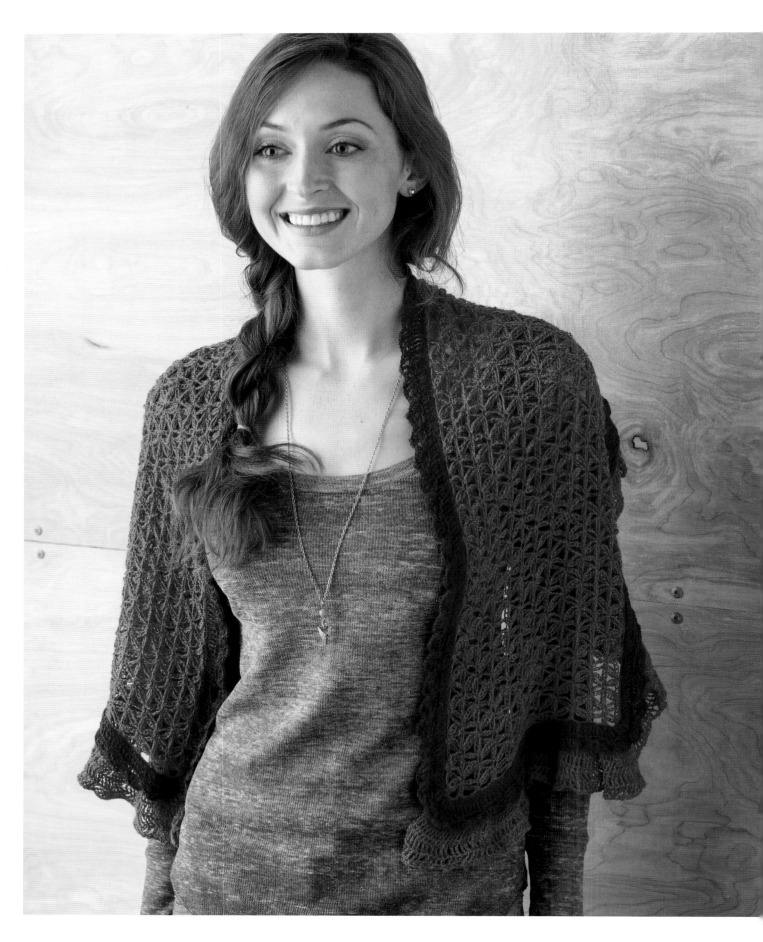

FINISHED SIZE
11" (28 cm) wide and 52"
(132 cm) long, including larger
ruffle edging.

MATERIALS

yarn
Laceweight (#0 Lace).

SHOWN HERE: Cascade Alpaca
Lace (100% baby alpaca;
437 yd/50 g): #1425 Provence
(MC), 2 skeins; #1415 Red Wine
Heather (CC), 1 skein.

hooks
C/2 (2.5 mm), D/3 (3.0 mm),
and E/4 (3.5 mm). *Adjust hook
size if necessary to obtain
correct gauge.*

notions
Darning needle; locking
stitch markers.

GAUGE
13 tr = 2" (5 cm) with medium-
sized hook.

starfish

I don't often use laceweight yarn in my designs; it is often too fragile- and delicate-looking for me. I love fabric that has durable texture and body. But this alpaca lace yarn inspired me to see how I could use it to make something in my style. I was amazed at how making the chain loops with a larger hook gives the crochet fabric a nice texture.

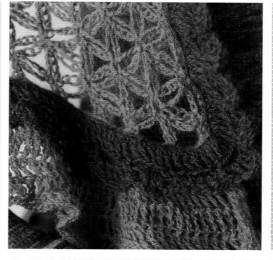

stitch guide

STARFISH STITCH PATTERN
(worked on a multiple of 6 sts, plus 2 sts)

ROW 1: Ch 1, sc in first tr, ch 9, sl st in first sc, *ch 4, sk next sc and ch-4 sp, sl st in next sc**, [ch 9, sl st in the same sc] twice; rep from * across, ending last rep at **, ch 9, sl st in the same sc, sc in last tr, turn.

ROW 2: Ch 6 (counts as tr and ch 2), sc in first 2 ch-9 lps, *ch 4, sc in each of next 2 ch-9 lps; rep from * across to last ch-9 lp, ch 2, tr in last sc, turn.

ROW 3: Ch 1, sc in first tr, ch 2, sk next ch-2 sp, *sl st in next sc, [ch 9, sl st in the same sc] twice**, ch 4, sk next sc and ch-4 sp; rep from * across, ending last rep at **, ch 2, sk next 2 ch, sc in 4th ch of beg ch-6, turn.

ROW 4: Ch 4 (counts as tr), sc in first ch-9 lp, *ch 4**, sc in each of next 2 ch-9 lps; rep from * across, ending last rep at **, sc into next ch-9 lp, tr in last sc, turn.

Rep Rows 1–4 for pattern.

instructions

Note: *The base shape of the scarf is a trapezoid that is made using 3 different sizes of crochet hook.*

BASE SCARF

With smallest hook and MC, ch 248.

Work Set-up Row (counts as Row 1) as foll:

SET-UP ROW: Ch 1, sc in 2nd ch from hook, *sc in next ch, ch 9, sl st in sc just made, ch 4, sk next 4 ch, sc in next ch, ch 9, sl st in sc just made; rep from * across, end with sc in last ch, turn.

ROWS 2–8: Work starfish stitch pattern (see Stitch Guide) Rows 2–4, then work Rows 1–4.

ROWS 9–16: Change to middle-sized crochet hook, work starfish stitch pattern Rows 1–4 twice.

ROWS 17–24: Change to largest hook, work starfish stitch pattern Rows 1–4 twice.

ROW 25: Ch 1, sc in first tr, *sc in next sc, ch 4, sc in next sc; rep from * across, end with sc in last tr. Do not turn.

LARGER RUFFLE EDGING

Turn the scarf 90 degrees to the right to work across shorter edge.

SET-UP ROW: Change to middle-sized hook with MC, start working Set-up Row from this corner across shorter edge to the other corner, then work along the longer edge and other shorter edge as foll:

(SHORTER EDGE) Ch 1, work sc into the top of last st on scarf, work 5 sc in next ch-4 sp, *sk next row-end sc, 5 sc in next ch-4 sp; rep from * across to next corner, sc in last row-end sc—62 sc.

(CORNER) You are at the corner now, working across opposite side of foundation ch, sc in first ch at base of first sc, and place a marker to mark the corner—1 sc.

(LONGER EDGE) Sc in next ch, work 5 sc in next ch-4 sp, *sk next 2 ch sts, 5 sc in next ch-4 sp; rep from * across to next corner, sc in next ch at base of sc—207 sc.

(CORNER) Sc in ch at base of last sc. Place a marker to mark the corner—1 sc.

STITCH KEY

◯ = chain (ch)

• = slip stitch (sl st)

╋ = single crochet (sc)

╪ = treble crochet (tr)

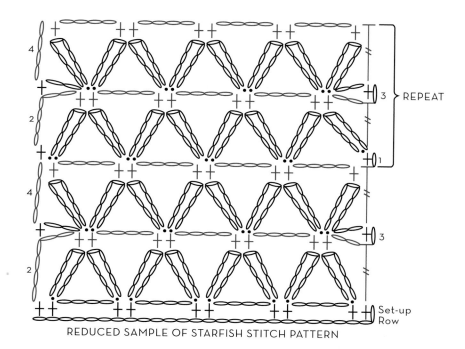

REDUCED SAMPLE OF STARFISH STITCH PATTERN

(OTHER SHORTER EDGE) Sc in first row-end sc, work 5 sc in next row-end tr, *sk next row-end sc, 5 sc next row-end tr; rep from * across to next corner, sc in last row-end sc, turn—62 sc; 233 sc total.

Work larger ruffle edging as foll:

ROW 1: Ch 4 (counts as tr here and throughout), sk first sc, working in flo of sts, ** *[2 tr in next sc, tr in next sc] twice, 2 tr in next sc*; rep from * to * across to within 1 sc of corner marked sc, tr in next sc, 3 tr in corner sc, do not remove marker, place another marker in the center tr of 3 tr to mark the corner st, tr in next sc; rep from ** across, rep from * to * across to last st, tr in last sc, place another marker in back lp of last sc, turn. This marker will stay in until smaller edging is worked later.

ROWS 2-5: Ch 4, sk first tr, *tr in each tr across to next marked corner st, 3 tr in marked corner st, replace marker in the center tr of 3 tr; rep from * once, tr in each tr to end of row, turn.

ROW 6: Ch 1, sc in first tr, (ch 1, sc) in each tr across 3 sides. Fasten off.

Remove the 2 corner markers from Row 6, leaving the markers placed in the back lp of the last sc in Row 1 and the corner markers in the Set-up Row.

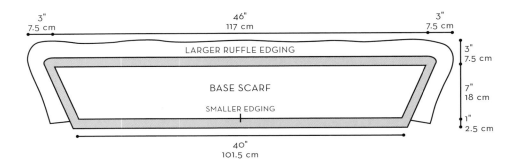

3"
7.5 cm

46"
117 cm

3"
7.5 cm

LARGER RUFFLE EDGING

3"
7.5 cm

BASE SCARF

7"
18 cm

SMALLER EDGING

1"
2.5 cm

40"
101.5 cm

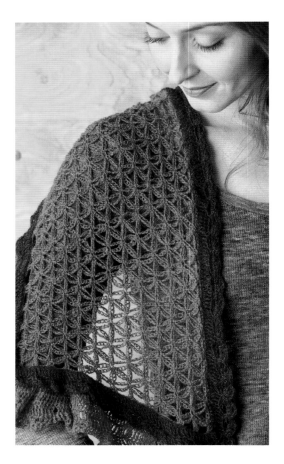

SMALLER EDGING

Note: *The first 333 sts of the smaller edging are worked through the front lps of the sts in the Set-up Row of larger ruffle edging. Only the front lps are showing on the scarf because the back lps were already used for working larger ruffle edging.*

Lay down scarf with ruffle edging at the top and the marked st on your right.

RND 1: With middle-sized hook and CC, working in remaining front lps of sts in Set-up Row, join yarn with a sl st in first marked st, ch 1, *sc in each st across to the corner marked st, sc in the corner st, replace marker in sc just worked; rep from * once, sc in each st to end of row—333 sc. Do not turn. You are at the corner of scarf at this point. Work along the rem long edge of the scarf as foll: Sc in first sc and place marker in sc just worked to mark corner st, sc in next sc, 6 sc into next ch-4 sp, [sk next 2 sc, 6 sc in next ch-4 sp, sk next 2 sc, 7 sc in next ch-4 sp] 19 times, 6 sc in each of next 2 ch-4 sps, sc in each of next 2 sc, place marker in last sc just worked to mark corner st, join with a sl st in first sc—269 sc on this edge; 602 sc total.

RND 2: Ch 4, sk first sc, working in blo of sts, *tr in each sc across to next marked corner sc 3, tr in the corner sc; rep from * 3 times, join with a sl st in top of beg ch-4—610 tr.

RND 3: Ch 1, sc in first tr, *ch 4, sk next 4 tr, sc in next tr; rep from * around to last 4 sts, sk next 4 tr, join with a sl st in first sc—122 ch-4 sps.

RND 4: Ch 1, sc in first sc, *[ch 1, tr] 3 times into ch-4 sp, ch 1**, sc in next sc; rep from * around, ending last rep at **, join with a sl st in first st.

RND 5: Ch 1, sc in first sc, sc in each st and ch-1 sp around, join with a sl st in first sc. Fasten off.

FINISHING

Weave in ends. Block scarf.

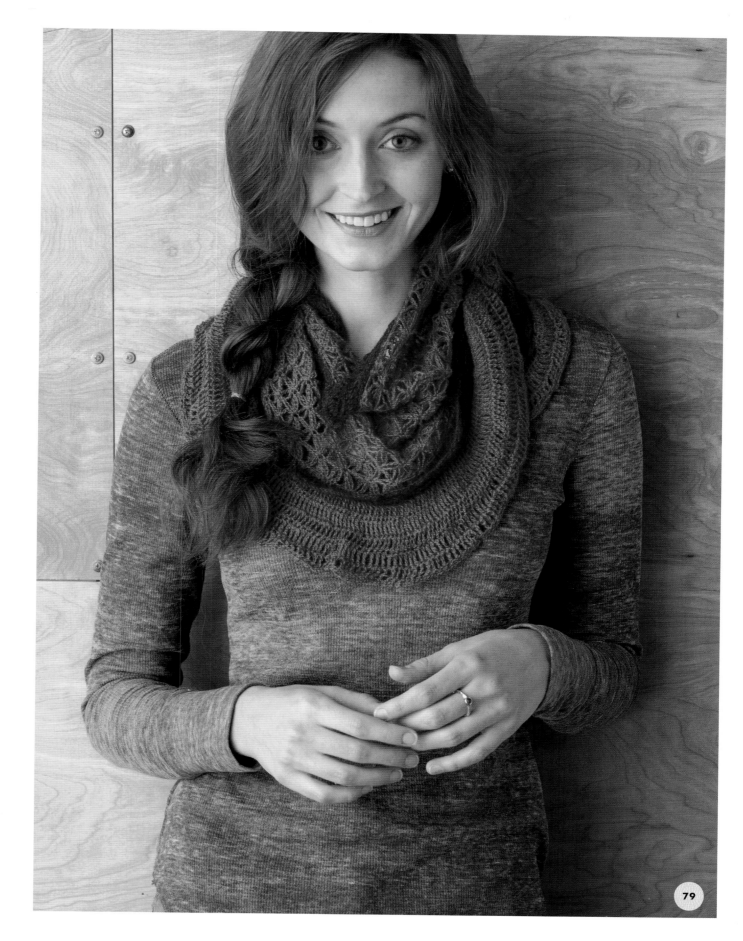

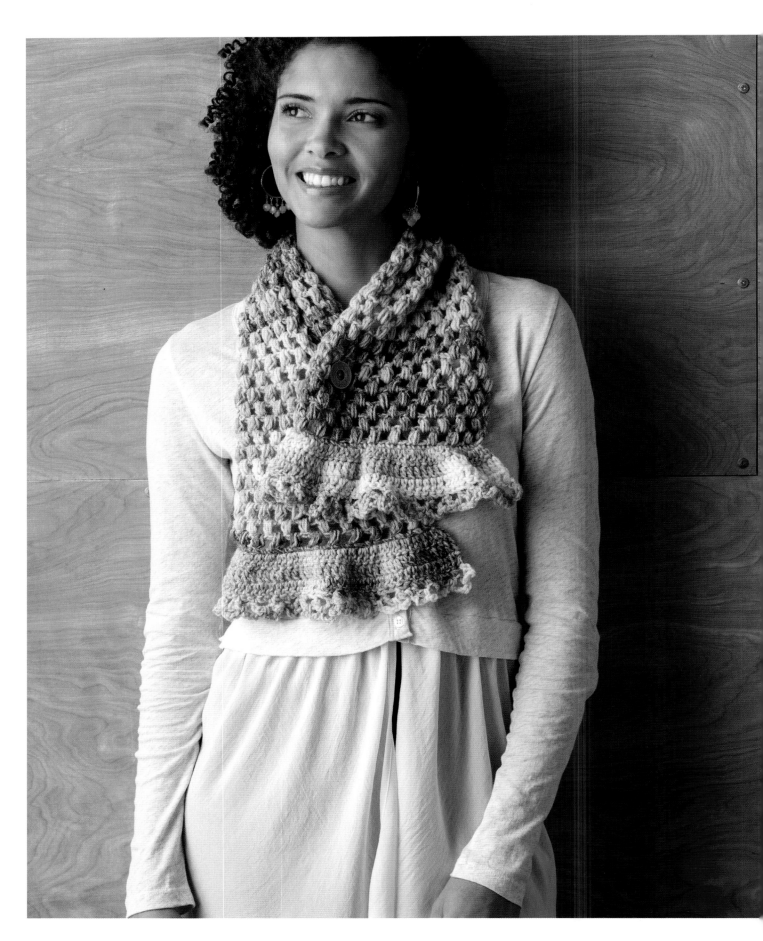

FINISHED SIZE
8" (20.5 cm) wide and 36"
(91.5 cm) long including ruffle
edgings.

MATERIALS
yarn
DK weight (#3 Light).

SHOWN HERE: James C. Brett
Woodlander DK (80% acrylic,
20% wool; 275 yd/100 g): #L9,
1 skein.

hook
J/10 (6.0 mm). *Adjust hook size
if necessary to obtain correct
gauge.*

notions
One 1" (2.5 cm) button; darning
needle.

GAUGE
4 pf = 3" (7.5 cm).

6 rows = 4" (10 cm) in puff
stitch pattern.

SEA *glass*

Here I used a self-striping shaded color yarn; I like the
color flow and that each end of the scarf looks different.
But this scarf is pretty simple and thus easy to change
to fit your style. A solid color yarn may work well; or
you could attach two or three contrasting color but-
tons, continue working and make a longer scarf without
buttons, or work a larger or longer ruffled edging.

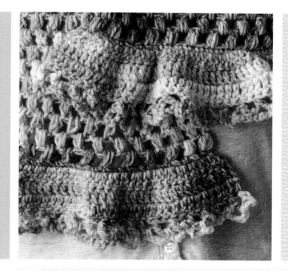

stitch guide

BEG PUFF ST (BEG PF)

Ch 2, [yo, insert hook in first st, yo, draw up a lp] twice, yo, draw through all 5 lps on hook, ch 1 to secure pf.

PUFF ST (PF)

Yo, insert hook in next st, yo and draw up a lp, [yo, insert hook in the same st, yo and draw up a lp] twice, yo, draw through all 7 lps on hook, ch 1 to secure pf.

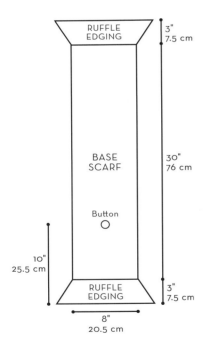

instructions

BASE SCARF

Ch 23.

ROW 1: Ch 2, yo, insert hook in 3rd ch from hook, yo, draw up a lp, yo, insert hook in the same ch, yo and draw up a lp, yo and draw through all 5 lps on hook, ch 1 to secure (counts as Beg pf), *ch 1, sk 1 ch, pf in next ch; rep from * across, turn—12 pf.

ROW 2: Ch 2 (counts as hdc), *pf into next ch-1 sp, ch 1; rep from * across to last ch-1 sp, then pf in last ch-1 sp, hdc in last pf, turn—11 pf.

ROW 3: Beg pf in first hdc, *ch 1, pf in next ch-1 sp; rep from * across, ending with last pf in last hdc instead of in ch-1 sp, turn—12 pf.

ROWS 4–47: Rep Rows 2 and 3 twenty-two times, or until work measures 30" (76 cm) from beg. Do not fasten off. Work ruffle edging as foll:

FIRST RUFFLE EDGING

ROW 1: Ch 1, sc in first pf, *sc in next ch-1 sp, sc in next pf; rep from * across, turn—23 sc.

ROW 2: Ch 3 (counts as dc here and throughout), dc in first sc, 2 dc in each of next 22 sc, turn—46 dc.

ROWS 3 AND 4: Ch 3, sk first dc, dc in each dc across, turn.

ROW 5: Ch 5, sk first dc, sc in next dc, *ch 4, sk next dc, sc in next dc; rep from * across, turn—24 ch-sps.

ROW 6: Ch 5, *sc in next ch-4 sp, ch 4; rep from * across, ending with sc in last ch-5 sp. Fasten off.

SECOND RUFFLE EDGING

ROW 1: Working in opposite side of foundation ch, join yarn in first ch, ch 1, sc in each ch across, turn—23 sc.

Work Rows 2–6 of first ruffle edging. Fasten off.

FINISHING

Weave in ends. Block scarf. Attach button at center of scarf, about 10" (25.5 cm) from end. Use any existing hole in the scarf as a buttonhole.

STITCH KEY

- ⬯ = chain (ch)
- • = slip stitch (sl st)
- ✚ = single crochet (sc)
- ⊤ = half double crochet (hdc)
- ⊤ = double crochet (dc)
- ⬭ = puff stitch (pf)

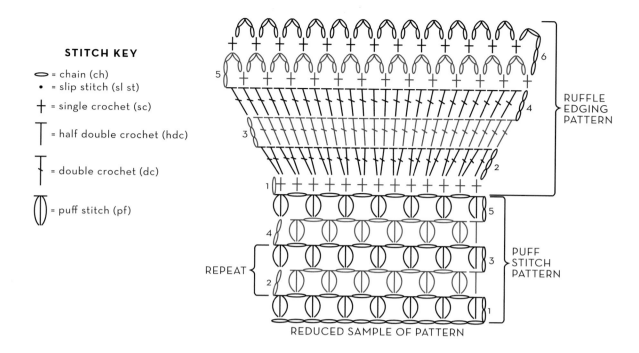

RUFFLE EDGING PATTERN

PUFF STITCH PATTERN

REPEAT

REDUCED SAMPLE OF PATTERN

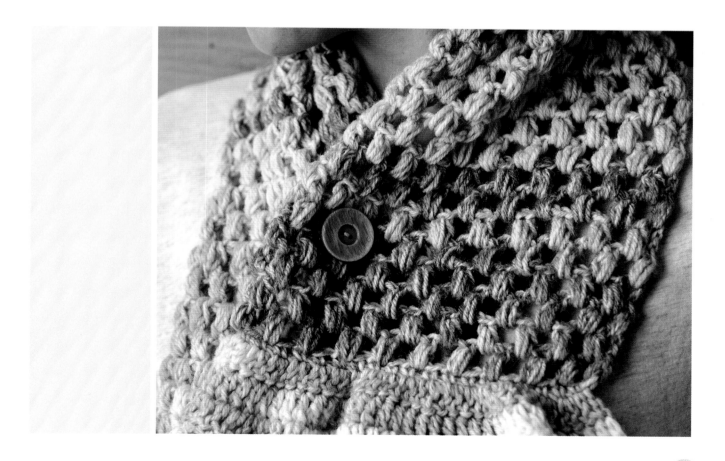

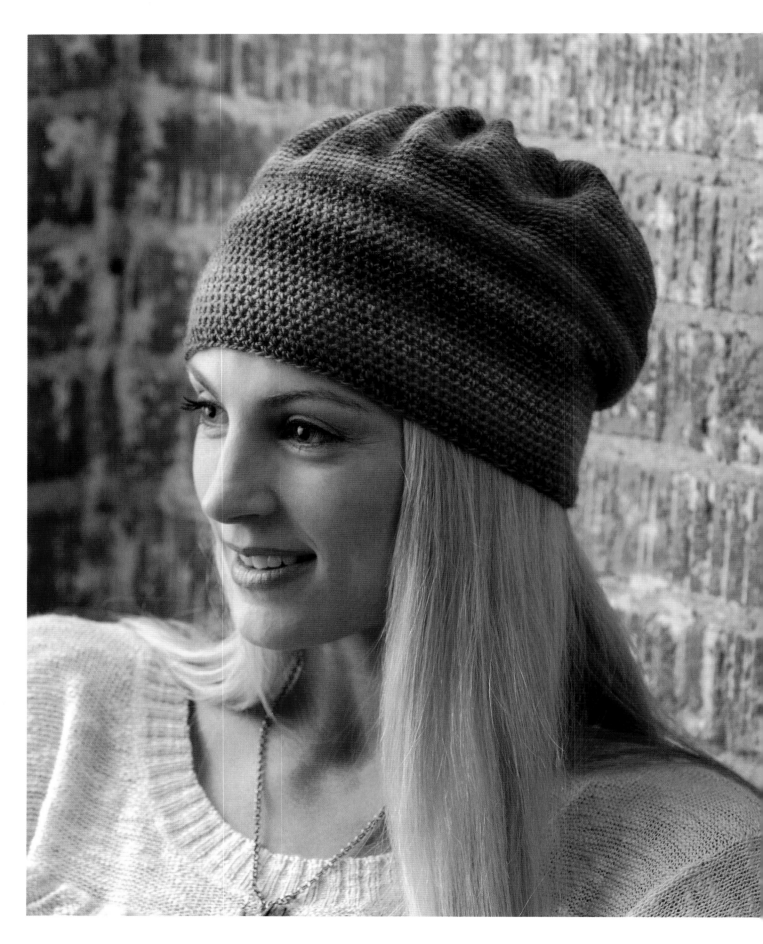

20" (51 cm) in circumference at brim and 9" (23 cm) deep from base of brim to center top of crown.

MATERIALS

yarn

Fingering weight (#1 Super Fine).

SHOWN HERE: Crystal Palace Yarns Sausalito (80% merino wool, 20% nylon; 198 yd/50 g): #8451 Harvest, 2 balls.

hook

E/6 (3.5 mm). *Adjust hook size if necessary to obtain correct gauge.*

notions

Darning needle; stitch markers.

GAUGE

21 hdc = 4" (10 cm), after blocking.

SEA *urchin*

This hat is simple yet stylish, with a gathered fabric. There is a simple star motif on top of the crown, and after you make it, just work single crochet on the crown and half crochet on the brim. The fabric has some stretch to it, so it is comfortable to wear.

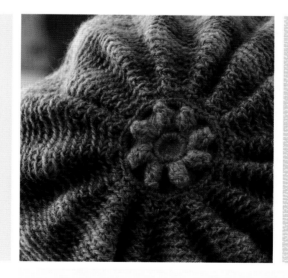

stitch guide

POPCORN (POP)
Work 5 dc in the same st, drop lp from hook, insert hook from front to back in top 2 lps of the first dc of 5-dc group, pick up dropped lp with hook and pull it through the st, then ch 1 to secure popcorn.

SC2TOG
[Insert hook in next st, draw up a lp] twice (3 lps on hook), yo, draw through all 3 lps on hook.

instructions

TOP OF CROWN

Ch 8, sl st in first ch to form a ring.

RND 1: Ch 1, 16 sc in ring, join with a sl st in first sc—16 sc.

RND 2: Ch 3 (counts as dc), work pop (see Stitch Guide) in first sc, *ch 3, sk next sc, pop in next sc; rep from * around, end with ch 3, join with a sl st in top of first pop—8 pops.

RND 3: Ch 1, sc in first pop, *5 sc in next ch-3 sp**, sc in next pop; rep from * around, ending last rep at **, join with a sl st in first sc—48 sc.

Note: *Work all sts in blo in Rnds 4-11.*

RND 4: Ch 1, place marker to mark beg of rnd, sk first sc, *3 sc in next sc**, sc in each of next 2 sc; rep from * around, ending last rep at **, sc in next sc, do not join. Work in a spiral. Move marker up into first st of each rnd as work progresses—1 ch and 79 sc.

RND 5: Sc in marked ch, replace marker in sc just worked, sc in each of next 79 sc—80 sc.

RND 6: Sc in next 2 sc, *3 sc in next sc**, sc in each of next 4 sc; rep from * around, ending last rep at **, sc in each of next 2 sc—112 sc.

RND 7: Sc in each sc around.

RND 8: Sc in each of next 3 sc, *3 sc in next sc**, sc in each of next 6 sc; rep from * around, ending last rep at **, sc in each of next 3 sc—144 sc.

RND 9: Rep Rnd 7.

RND 10: Sc in each of next 4 sc, *3 sc in next sc**, sc in each of next 8 sc; rep from * around, ending last rep at **, sc in each of next 4 sc—176 sc.

RND 11: Rep Rnd 7.

Cont to rep Rnd 11, still working in the blo, until the hat measures 5¼" (13.5 cm) from the top, then work the brim as foll:

BRIM

Note: *Work all sts through both lps of sts.*

RND 1: Sc in next sc, *[sc2tog over next 2 sts] twice (see Stitch Guide), sc in next st; rep from * around—106 sc.

RND 2: Hdc in marked sc, replace marker in hdc just worked, hdc in each of next 105 sc around—106 hdc.

RND 3: Hdc in each hdc around.

Cont to rep Rnd 3 until hat measures 9" (23 cm) from the center top, then work as foll:

Hdc in each of next 105 hdc, sc in next hdc, sl st in next hdc. Fasten off.

FINISHING

Remove marker. Weave in ends. Block hat.

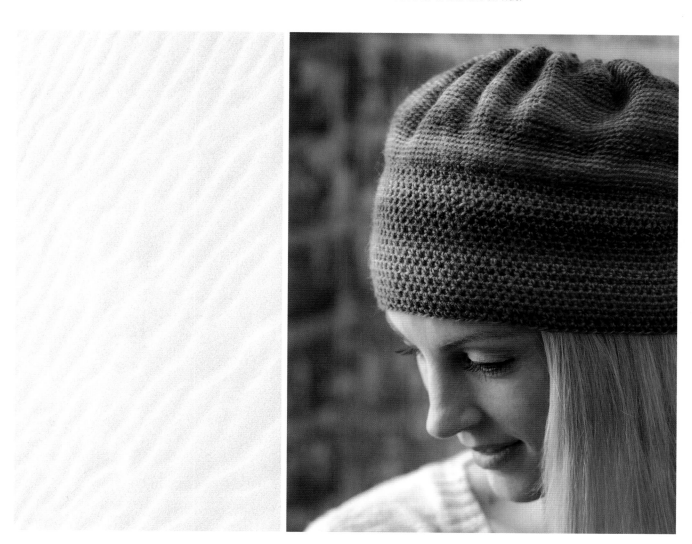

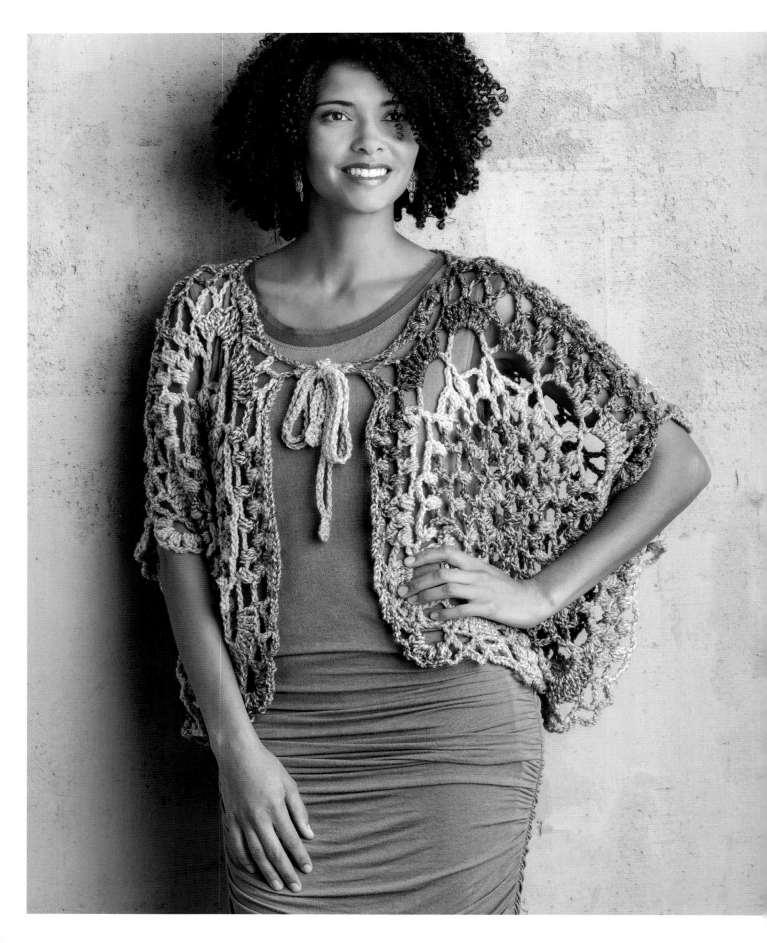

FINISHED SIZE
One size fits most.

20" (51 cm) long and 40" (101.5 cm) wide.

MATERIALS
yarn
Chunky weight (#5 Bulky).

SHOWN HERE: James C. Brett Marble Chunky (100% acrylic; 341 yd/200 g): #MC9, 2 balls.

hook
7.0 mm (no exact equivalent in U.S. sizing). *Adjust hook size if necessary to obtain correct gauge.*

notions
Darning needle.

GAUGE
First 3 rnds of motif = 8" (20.5 cm) in diameter, after blocking.

FLOATING *net*

You'd never know that this garment is made with four big rounded square motifs—one for the right front, one for the left front, and two for the back! Using lighter weight yarn with a smaller hook will make a bolero-like garment, and super chunky weight yarn with a larger hook will make a poncho-like garment.

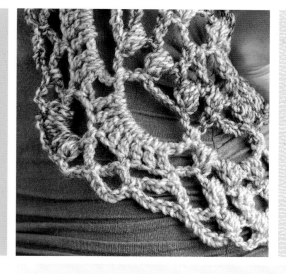

note

The garment is made by connecting 4 motifs. The foll instructions are for making one motif and connecting the other motifs by joining as you go. This method is easier for me, but, if you prefer, you can make the 4 motifs separately and then join them with extra yarn and a darning needle.

stitch guide

PUFF ST (PF)

Yo, insert hook in next st, yo, draw up a lp, [yo, insert hook in same st, yo, draw up a lp] twice, yo, draw through all 7 lps on hook, ch 1 to secure puff.

HALF TREBLE CROCHET (HTR)

Yo (twice), insert hook in next st, yo, draw up a lp, yo, draw through 2 lps on hook, yo and draw through 3 lps on hook.

instructions

MOTIF A

BASE RING: Ch 10, sl st in first ch to form a ring.

RND 1: Ch 2, pf (see Stitch Guide) in ring, [ch 3, pf] 7 times in ring, ch 3, join with a sl st in first pf—8 pfs.

RND 2: Sl st in first ch-3 sp, ch 6 (counts as dc, ch 3), dc in first ch-3 sp, *ch 3, (dc, ch 3, dc) in next ch-3 sp; rep from * around, ch 3, join with a sl st in 3rd ch of ch-6—16 ch-3 sps.

RND 3: Sl st in first ch-3 sp, ch 2, pf in same ch-3 sp, *ch 3, pf in next ch-3 sp; rep from * around, ch 3, join with a sl st in first pf—16 pfs.

RND 4: Rep Rnd 2—32 ch-3 sps.

RND 5: Rep Rnd 3—32 pfs.

RND 6: Sl st in first ch-3 sp, ch 1, sc in first ch-3 sp, *ch 8, sk next ch-3 sp, sc in next ch-3 sp; rep from * around, ch 8, join with a sl st in first sc.

RND 7: Sl st in first ch-8 sp, ch 2, [pf, ch 2] 3 times in first ch-8 sp, [pf, ch 2] 3 times in next ch-8 sp, 8 htr (see Stitch Guide) in each of next 2 ch-8 sps, *ch 2, [pf, ch 2] 3 times in each of next 2 ch-8 sps, 8 htr in each of next 2 ch-8 sps; rep from * around, ch 2, join with a sl st in first pf.

RND 8: Sl st in first ch-2 sp, ch 2, pf in same ch-2 sp, *[ch 2, pf] in each of next 4 ch-2 sps, ch 5, [sc in next htr, ch 5, sk next 2 htr] 5 times, sc in next htr, ch 5**, sk next ch-2 sp, pf in next ch-2 sp; rep from * around, ending last rep at **, join with a sl st in first pf.

RND 9: Sl st in first ch-2 sp, ch 2, pf in same ch-2 sp, *(ch 3, pf) in each of next 3 ch-2 sps, (ch 5, sc) in each of next 3 ch-5 sps, ch 3, ([pf, ch 1] 3 times, pf) in next ch-2 sp for corner, ch 3, sc in next ch-5 sp, (ch 5, sc) in each of next 2 ch-5 sps, ch 5**, pf in next ch-2 sp; rep from * around, ending last rep at **, join with a sl st in first pf. Fasten off.

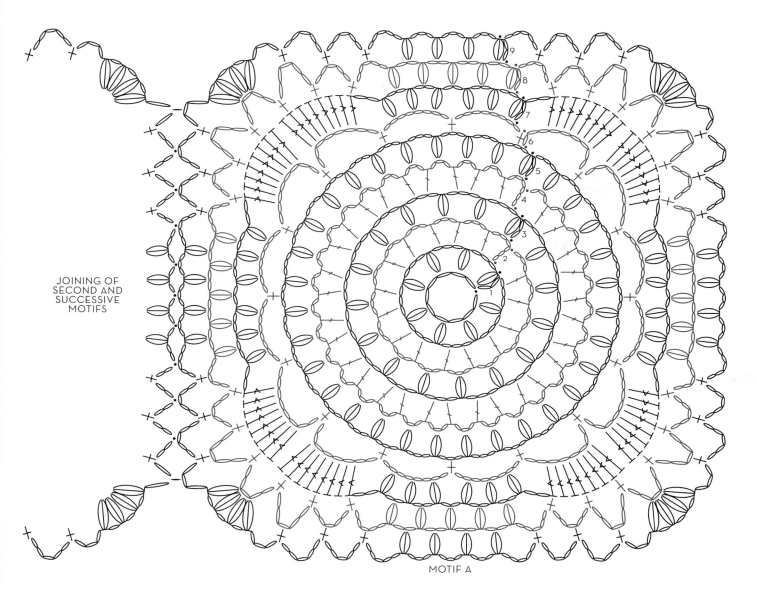

JOINING OF
SECOND AND
SUCCESSIVE
MOTIFS

MOTIF A

STITCH KEY

⬭ = chain (ch)

• = slip stitch (sl st)

+ = single crochet (sc)

↑ = double crochet (dc)

↑ = half treble crochet (htr)

◍ = puff stitch (pf)

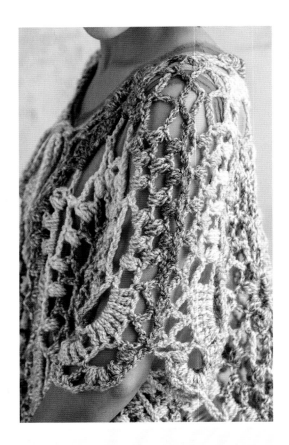

MOTIF B

Note: The 4 groups of puffs with just 1 ch between each pf in Rnd 9 form the "corners" of each motif (hereafter referred to as "4-puffs rnd corners").

Work same as motif A through Rnd 8, then while working Rnd 9, join one edge (between the 4-puffs rnd corners) of motif B to motif A as foll:

RND 9: Sl st in first ch-2 sp, ch 2, pf in same ch-2 sp, (ch 3, pf) in each of next 3 ch-2 sps, (ch 5, sc) in each of next 3 ch-5 sps, ch 3, ([pf, ch 1] 3 times, pf) in next ch-2 sp, ch 1, sl st in corresponding ch-3 sp of previous motif, ch 1, sc in next ch-5 sp on current motif, [ch 2, sl st in next ch-5 sp on adjacent motif, ch 2, sc] in each of next 3 ch-5 sps**, [pf, ch 1, sl st in next ch-3 sp on adjacent motif, ch 1] in each of next 3 ch-2 sps, pf in next ch-2 sp, [ch 2, sl st in next ch-5 sp on adjacent motif, ch 2, sc] in each of next 3 ch-5 sps, ch 1, sl st in next ch-3 sp on adjacent motif, ch 1, pf in next ch-2 sp, *([pf, ch 1] 3 times, pf) in next ch-2 sp, ch 3, sc in next ch-5 sp, [ch 5, sc] in each of next 2 ch-5 sps, ch 5**, pf in next ch-2 sp, (ch 3, pf) in each of next 3 ch-2 sps, (ch 5, sc) in each of next 3 ch-5 sps, ch 3; rep from * around, ending last rep at **, join with a sl st in first pf. Fasten off.

MOTIF C

Work same as motif B, joining to right side of motif B (**figure 1**).

MOTIF D

Work same as motif B, joining to bottom side of motif C (**figure 1**).

FINISHING

Armhole (optional): Find a ch-5 or ch-3 sp that is a comfortable place for you to sew the underarm. With darning needle, sew the corresponding ch-5/ch-3 sp on front motif and back motif tog. Weave in ends. Block garment.

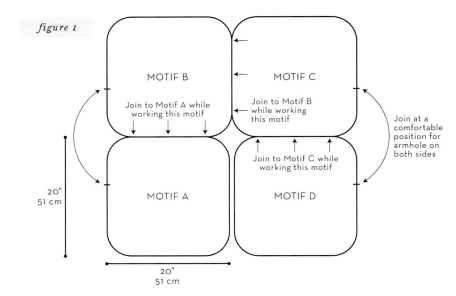

figure 1

MOTIF B — Join to Motif A while working this motif

MOTIF C — Join to Motif B while working this motif

MOTIF A

MOTIF D — Join to Motif C while working this motif

Join at a comfortable position for armhole on both sides

20"
51 cm

20"
51 cm

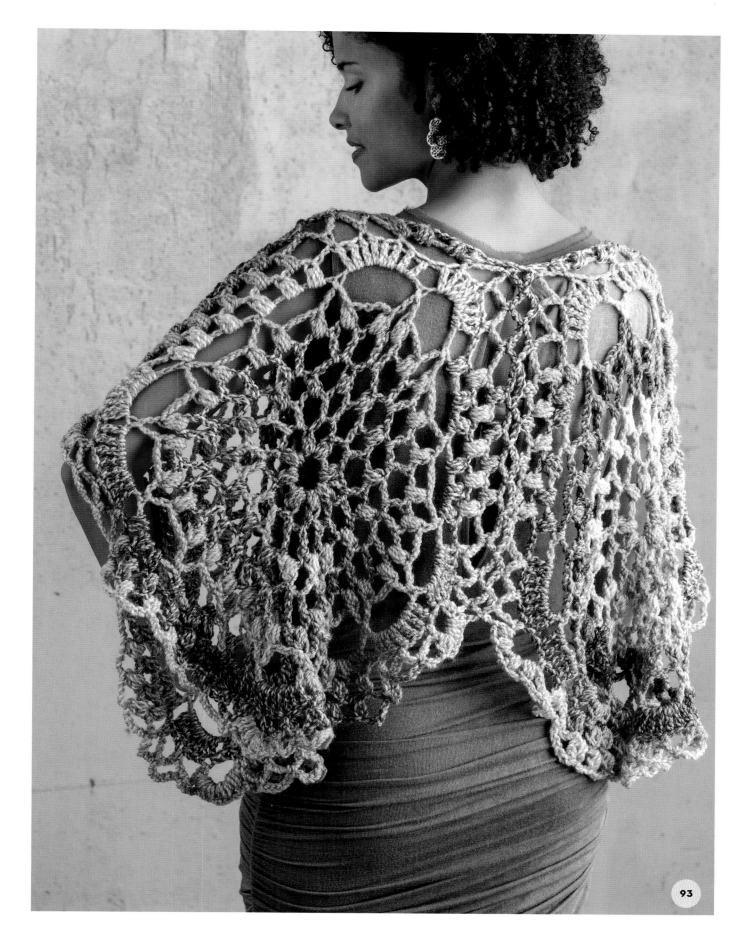

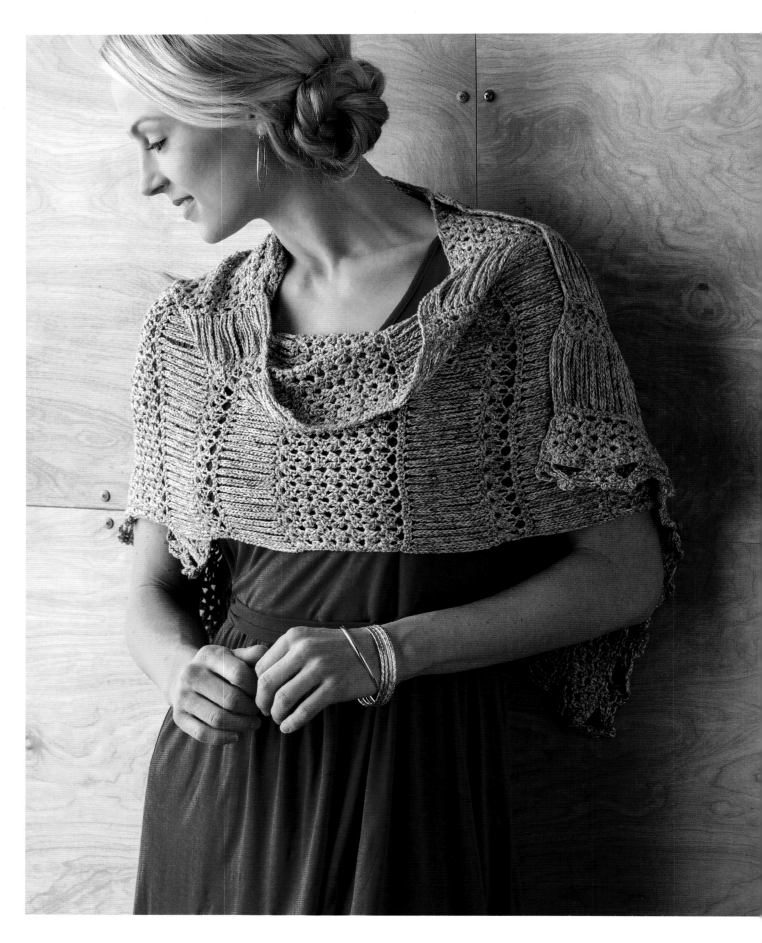

driftwood

This design combines chain lace, straight lines, and a fan lace pattern. The curvy line gives the fabric a good balance and shows both stitch patterns well. Using the same pattern but with different lengths creates a nice design flow.

FINISHED SIZE
15½" (39.5 cm) wide and 76" (193 cm) long.

MATERIALS
yarn
Fingering weight (#1 Super Fine).

SHOWN HERE: Schachenmayr SMC Egypto Cotton Color (100% cotton; 197 yd/50 g): #82 Olive Mix, 6 balls.

hook
E/4 (3.5 mm). *Adjust hook size if necessary to obtain correct gauge.*

notions
Darning needle.

GAUGE
12 sts = 2" (10 cm) in main stitch pattern, after blocking.

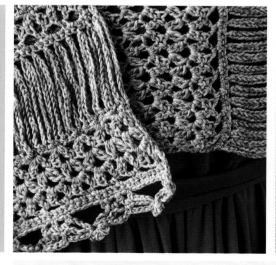

stitch guide

2 DOUBLE CROCHET CLUSTER (2DC-CL)

Yo, insert hook in next st, yo, draw up a lp, yo, draw through 2 lps on hook, yo, insert hook in same st, yo, draw up a lp, yo, draw through 2 lps on hook, yo, draw through all 3 lps on hook.

MAIN STITCH PATTERN
(worked on a multiple of 4 sts, plus 1 st)

SET-UP ROW: Ch 1, sc in 2nd ch from hook and in each ch across, turn.

ROW 1: Ch 3 (counts as dc here and throughout), sk first 2 sc, (2dc-cl, ch 3, 2dc-cl) in next sc, *sk next 3 sc, (2dc-cl, ch 3, 2dc-cl) in next sc; rep from * across to last 2 sts, sk next sc, dc in last sc, turn.

ROW 2: Ch 3, *(2dc-cl, ch 3, 2dc-cl) into next ch-3 sp between 2dc-cl; rep from * across, dc in last dc, turn.

ROWS 3–7: Rep Row 2.

ROW 8: Ch 4 (counts as dc, ch 1), sc in next ch-3 sp, *ch 3, sc in next ch-3 sp; rep from * across to last ch-3 sp, ch 1, dc in last dc, turn.

ROW 9: Ch 1, sc in first dc, sc in next ch-1 sp, *sc in next sc, 3 sc in next ch-3 sp; rep from * across to last ch-3 sp, sc in next sc, sc in next ch-1 sp, sc in last dc, turn.

ROW 10: Ch 30, sk first sc, sl st in next sc, *ch 30, sk next sc, sl st in next sc; rep from * across, end with ch 30, sl st in last sc, turn.

ROW 11: Ch 15, sc in first ch-30 lp, *ch 1, sc in next ch-30 lp; rep from * across, turn.

ROW 12: Ch 1, sc in first sc, *sc in next ch-1 sp, sc in next sc; rep from * across, turn.

ROW 13: Rep Row 1.

ROWS 14–18: Rep Rows 8–12.

instructions

Note: *Shawl is composed of Sections 1–6 (see diagram at right). Work in main stitch pattern Rows 1–18 in each section except where instructed otherwise. Work 50 chs instead of 30 chs for Section 2 and Section 5; follow the instructions carefully. Beg with Section 1, cont working to Sections 2–6 as follows.*

SECTION 1: Ch 93, work main stitch pattern (see Stitch Guide) Set-up Row and Rows 1–3, sk Rows 4–7, then work Rows 8–18.

SECTION 2: Work main stitch pattern Rows 1–18, but work ch 50 instead of 30 on Row 10 and Row 16. Then work ch 25 instead of 15 at the beg of Rows 11 and 17.

SECTION 3: Work main stitch pattern Rows 1–18.

SECTION 4: Work main stitch pattern Rows 1–18.

SECTION 5: Work main stitch pattern Rows 1–18, but work ch 50 instead of 30 on Row 10 and Row 16. Then work ch 25 instead of 15 at the beg of Rows 11 and 17.

SECTION 6: Work main stitch pattern Rows 1–18.

After section 6, work main stitch pattern Rows 1–3, sk Rows 4–7, then work Rows 8 and 9.

Do not fasten off. Cont working on the edging as foll:

FIRST EDGING

ROW 1: Ch 1, sc in first sc, sc in each sc across, turn—93 sc.

ROW 2: Ch 1, sc in first sc, ch 3, sk next sc, sc in next sc, ch 10, sk next 6 sc, sc in next sc, *[ch 3, sk next sc, sc in next sc] twice, ch 10, sk next 5 sc, sc in next sc; rep from * 6 times, (ch 3, sk 1 sc, sc in next sc) twice, ch 10, sk next 6 sc, sc in next sc, ch 3, sk next sc, sc in last sc, turn—9 ch-10 sps.

ROW 3: Ch 3, sc in next ch-3 sp, *ch 5, sc in next ch-10 sp, (ch 5, sc) in each of next 2 ch-3 sps; rep from * 7 times, ch 5, sc in next ch-10 sp, ch 5, sc into next ch-3, ch 1, hdc in last sc, turn.

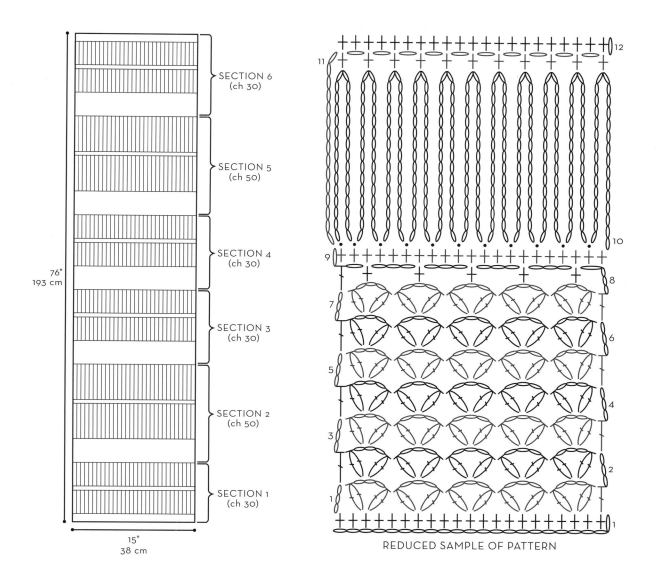

SECTION 6
(ch 30)

SECTION 5
(ch 50)

SECTION 4
(ch 30)

SECTION 3
(ch 30)

SECTION 2
(ch 50)

SECTION 1
(ch 30)

76"
193 cm

15"
38 cm

REDUCED SAMPLE OF PATTERN

STITCH KEY

⬭ = chain (ch)
• = slip stitch (sl st)
✚ = single crochet (sc)
┰ = half double crochet (hdc)
† = double crochet (dc)
⑂ = 2 double crochet
 cluster (2dc-cl)

REDUCED SAMPLE OF EDGING PATTERN

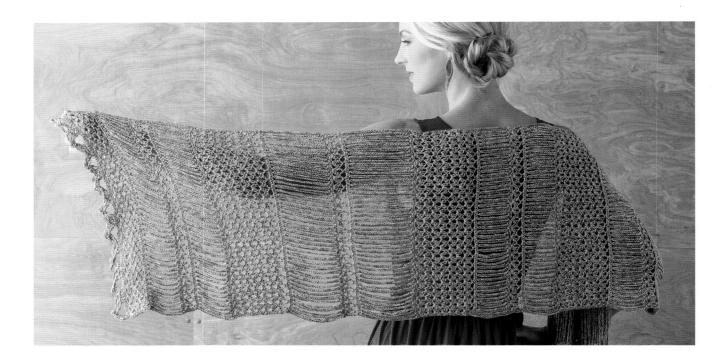

ROW 4: Ch 1, sc in next ch-1 sp, *ch 6, sk next ch-5 sp, ([sl st, ch 3] 3 times, sl st) in next sc, ch 6, sc in next ch-3 sp; rep from * across. Fasten off.

SECOND EDGING

ROW 1: With WS facing, working across opposite side of foundation ch, join yarn in first ch, ch 1, sc in first ch, sc in each ch across, turn—93 sc.

Rep Rows 2 and 3 of first edging.

FINISHING

Weave in ends. Block shawl.

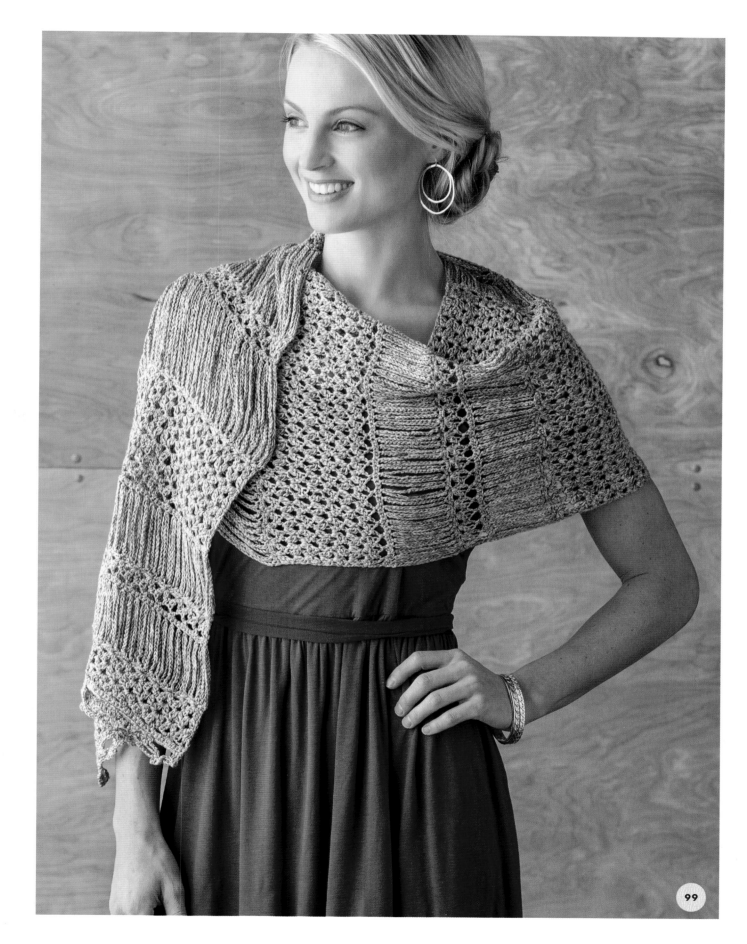

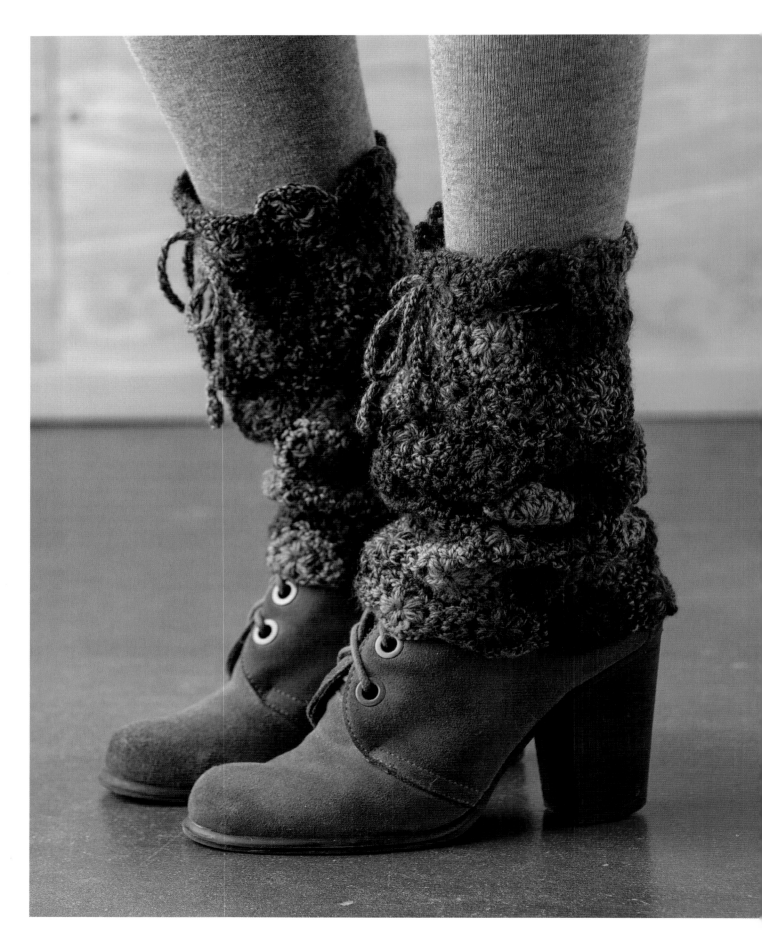

FINISHED SIZE
13" (33 cm) in circumference and 11" (28 cm) long.

MATERIALS
yarn
Sportweight (#3 Light).

SHOWN HERE: Schoppel Wolle Zauberball Starke 6 (75% superwash wool, 25% nylon; 437 yd/150 g): #2037 Country, 1 ball.

hook
F/7 (3.75 mm). *Adjust hook size if necessary to obtain correct gauge.*

notions
Darning needle.

GAUGE
Flower motif = 1¾" (4.5 cm) in diameter.

BEACH *pebbles*

I love working crocheted motifs with self-striping yarn. The yarn comes through totally differently than it does when it is knitted, or crocheted back and forth. When I made the flower motif with self-striping yarn, it looks like a free-form motif. These leg warmers are made by connecting simple flower motifs as you go, so there's no sewing to do at the end.

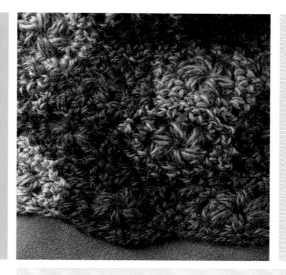

stitch guide

PUFF ST (PF)

Yo, insert hook in next st, yo, draw up a lp, [yo, insert hook in same st, yo, draw up a lp] twice, yo, draw through all 7 lps on hook, ch 1 to secure puff.

FLOWER MOTIF PATTERN

BASE RING: Ch 4, sl st in first ch to form a ring.

RND 1: Ch 2, [pf, ch 3] 6 times in ring, join with a sl st in first pf.

RND 2: Ch 1, sc in first pf, *ch 3, sc in next ch-3 sp, ch 3**, sc in next pf; rep from * around, ending last rep at **, join with a sl st in first sc. Fasten off.

instructions

Make 64 flower motifs (see Stitch Guide) for each leg warmer and join all motifs using the join-as-you-go method as shown in diagrams, according to section below.

HOW TO JOIN AS YOU GO

Beg with 1 complete motif, then join subsequent motifs in Rnd 2 as you make them. Join to 2 or 3 sets of ch-3 sps of completed motif by working (ch 1, sl st in ch-3 sp of completed motif, ch 1) in place of ch-3 in Rnd 2.

Note: *Motifs are joined as in diagrams. The diagrams were drawn flat, but the actual leg warmer is tube shaped. The 8 motifs on the top around the knee and the bottom row around the ankle are joined at 3 sets of ch-3 sp on 2 sides of each motif. All other motifs are joined at 2 sets of ch-3 sps on each side. (The numbers on the diagram represent the number of ch-3 sps joined at the side of each motif.)*

BODY
(make 2)

Ch 3, 3 dc in 3rd ch from hook, ch 2, sl st in the same ch where 3 dc were worked, ch 150, then ch 3, 3dc in 3rd ch from hook, ch 2, sl st in the same ch where 3 dc were worked, sl st in next ch, sl st in each ch across until the ch where 3 dc were worked at beg. Fasten off.

WEAVING CORDS

On each leg warmer, weave a cord through the sps between motifs between the top row and the second row from the top. Pull at both ends of the cords to adjust the fit of the leg warmers.

FINISHING

Weave in ends.

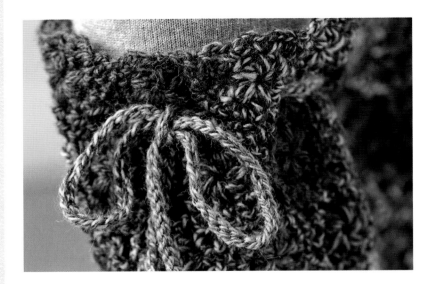

STITCH KEY

◯ = chain (ch)

• = slip stitch (sl st)

✛ = single crochet (sc)

⬭ = puff stitch (pf)

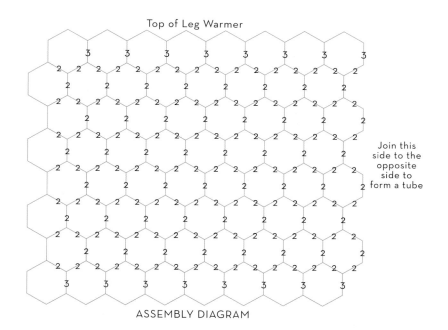

Top of Leg Warmer

Join this side to the opposite side to form a tube

ASSEMBLY DIAGRAM

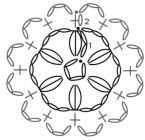

FIRST
FLOWER MOTIF

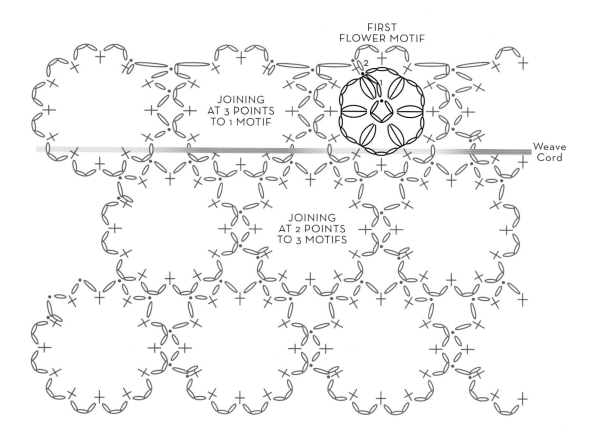

FIRST
FLOWER MOTIF

JOINING
AT 3 POINTS
TO 1 MOTIF

JOINING
AT 2 POINTS
TO 3 MOTIFS

Weave
Cord

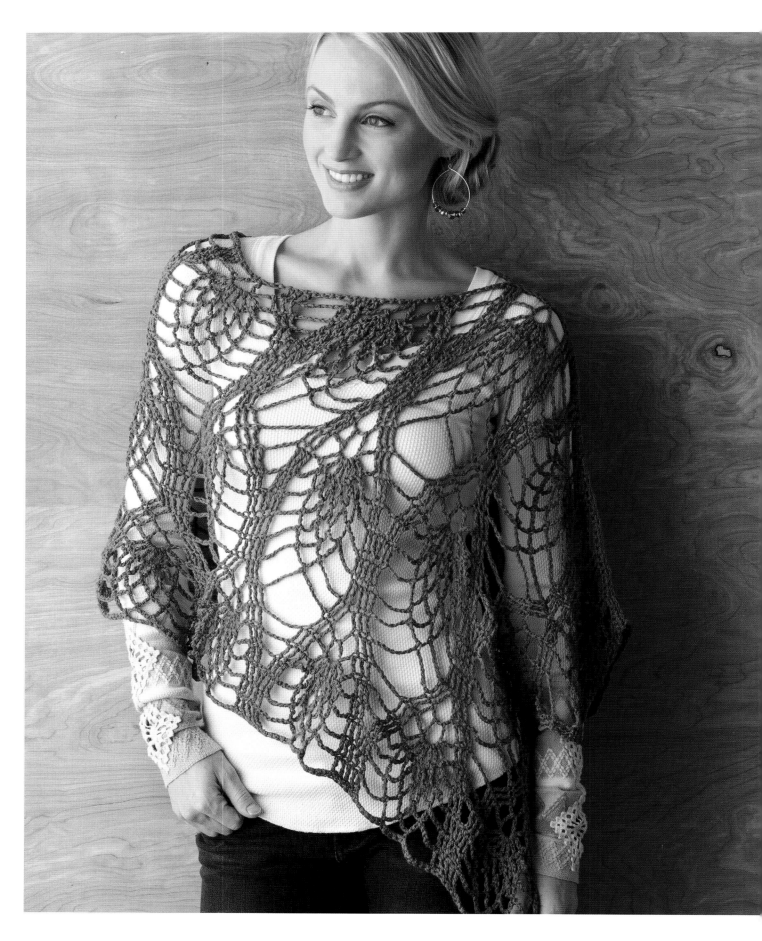

FINISHED SIZE
60" (152.5 cm) in circumference
and 22" (56 cm) long.

MATERIALS
yarn
DK weight (#3 Light).

SHOWN HERE: Schulana Kilino
(53% linen, 47% cotton; 126
yd/50 g): #34 Cocoa, 5 balls.

hook
H/8 (5.0 mm) hook. *Adjust
hook size if necessary to
obtain correct gauge.*

notions
Darning needle.

GAUGE
13 sts = 4½" (11.5 cm) in body
stitch pattern after blocking.

SEA *turtle*

This lace design is a specialty that can only be created with crochet. It will be good for many seasons, so work this pattern in many different yarns! This poncho is made using a rectangle-shaped piece of crocheted fabric. The edge of the sleeve has a curvy shape created by the pineapple stitch pattern.

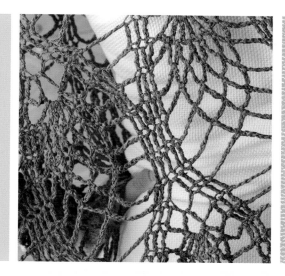

stitch guide

TREBLE CROCHET 2 TOGETHER (TR2TOG)
Yo (twice), insert hook in next st, yo and draw up a lp, [yo and draw through 2 lps on hook] twice, sk next ch-1 sp, yo (twice), insert hook in next st, yo and draw up a lp, [yo and draw through 2 lps on hook] twice, yo, draw through all 3 lps on hook.

BODY STITCH PATTERN
(worked on a multiple of 18 sts, plus 13 sts)

SET-UP ROW 1: Ch 1, sc in 2nd ch from hook and in each ch across, turn.

SET-UP ROW 2: Ch 4 (counts as tr here and throughout), sk first sc, tr in each of next 2 sc, *sk next 3 sc, (ch 3, tr, ch 3, tr, ch 3) in next sc, sk next 3 sc, tr in each of next 3 sc**, ch 5, sk next 5 sc, tr in each of next 3 sc; rep from * across, ending last rep at **, turn.

ROW 1: Ch 4, sk first tr, tr in each of next 2 tr, *sk next ch-3 sp, [ch 1, tr] 7 times in next ch-3 sp, ch 1, sk next ch-3 sp, tr in each of next 3 tr**, ch 5, tr in each of next 3 tr; rep from * across, ending last rep at **, turn.

ROW 2: Ch 4, sk first tr, tr in each of next 2 tr, *ch 5, sk next ch-1 sp, sc in next ch-1 sp, (ch 6, sc) in each of next 5 ch-1 sps, ch 5, sk next ch-1 sp, tr in each of next 3 tr**, ch 3, tr in each of next 3 tr; rep from * across, ending last rep at **, turn.

ROW 3: Ch 4, sk first tr, tr in each of next 2 tr, *ch 5, sk next ch-5 sp, sc in next ch-6 sp, (ch 6, sc) in each of next 4 ch-6 sps, ch 5, sk next ch-5 sp, tr in each of next 3 tr**, ch 1, sk next ch-5 sp, tr in each of next 3 tr; rep from * across, ending last rep at **, turn.

ROW 4: Ch 4, sk first tr, tr in each of next 2 tr, *ch 5, sk next ch-5 sp, sc in next ch-6 sp, (ch 6, sc) in each of next 3 ch-6 sps, ch 5, sk next ch-5 sp, tr in each of next 2 tr**, tr2tog over next 2 tr (skipping ch-1 sp between), tr in each of next 2 tr; rep from * across, ending last rep at **, tr in last tr, turn.

ROW 5: Ch 4, sk first tr, tr in each of next 2 tr, *ch 6, sk next ch-5 sp, sc in next ch-6 sp, (ch 6, sc) in each of next 2 ch-6 sps, ch 6, sk next ch-5 sp, tr in each of next 2 tr**, tr in tr2tog, tr in each of next 2 tr; rep from * across, ending last rep at **, tr in last tr, turn.

ROW 6: Ch 4, sk first tr, tr in each of next 2 tr, *ch 7, sk next ch-6 sp, sc in next ch-6 sp, ch 6, sc in next ch-6 sp, ch 7, sk ch-6 sp**, tr in each of next 5 tr; rep from * across, ending last rep at **, tr in each of last 3 tr, turn.

ROW 7: Ch 4, sk first tr, tr in each of next 2 tr, *ch 8, sk next ch-7 sp, sc in ch-6 sp, ch 8, sk next ch-7 sp, tr in

each of next 2 tr**, (tr, ch 5, tr) in next tr, tr in each of next 2 tr; rep from * across, ending last rep at **, tr in last tr, turn.

ROW 8: Ch 4, sk first tr, tr in each of next 2 tr, *ch 7, sk next 2 ch-8 sps, tr in each of next 3 tr**, ch 3, (tr, ch 3, tr) in next ch-5 sp, ch 3, tr in each of next 3 tr; rep from * across, ending last rep at **, turn.

ROW 9: Ch 4, sk first tr, tr in each of next 2 tr, *ch 5, sk next ch-7 sp, tr in each of next 3 tr**, sk next ch-3 sp, [ch 1, tr] 7 times in next ch-3 sp, ch 1, sk next ch-3 sp, tr in each of next 3 tr; rep from * across, ending last rep at **, turn.

ROW 10: Ch 4, sk first tr, tr in each of next 2 tr, *ch 3, sk next ch-5 sp, tr in each of next 3 tr**, ch 5, sk next ch-1 sp, sc in next ch-1 sp, (ch 6, sc) in each of next 5 ch-6 sps, ch 5, sk next ch-1 sp, tr in each of next 3 tr; rep from * across, ending last rep at **, turn.

ROW 11: Ch 4, sk first tr, tr in each of next 2 tr, *ch 1, sk next ch-3 sp, tr in each of next 3 tr**, ch 5, sk next ch-5 sp, sc in next ch-6 sp, (ch 6, sc) in each of next 4 ch-6 sps, ch 5, sk next ch-5 sp, tr in each of next 3 tr; rep from * across, ending last rep at **, turn.

ROW 12: Ch 4, sk first tr, tr in next tr, *tr2tog over next 2 tr (skipping ch-1 sp between), tr in each of next 2 tr**, ch 5, sk next ch-5 sp, sc in next ch-6 sp, (ch 6, sc) in each of next 3 ch-6 sps, ch 5, sk ch-5 sp, tr in each of next 2 tr; rep from * across, ending last rep at **, turn.

ROW 13: Ch 4, sk first tr, tr in next tr, *tr in next tr2tog, tr in each of next 2 tr**, ch 6, sk next ch-5 sp, sc in next ch-6 sp, (ch 6, sc) in each of next 2 ch-6 sps, ch 6, sk next ch-5 sp, tr in each of next 2 tr; rep from * across, ending last rep at **, turn.

ROW 14: Ch 4, sk first tr, tr in each of next 4 tr, *ch 7, sk next ch-6 sp, sc in next ch-6 sp, ch 6, sc in next ch-6 sp, ch 7, sk next ch-6 sp, tr in each of next 5 tr; rep from * across, turn.

ROW 15: Ch 4, sk first tr, tr in next tr, *(tr, ch 5, tr) in next tr, tr in each of next 2 tr**, ch 8, sk next ch-7 sp, sc in next ch-6 sp, ch 8, sk next ch-7 sp, tr in each of next 2 tr; rep from * across, ending last rep at **, turn.

ROW 16: Ch 4, sk first tr, tr in each of next 2 tr, *ch 3, (tr, ch 3, tr) in next ch-5 sp, ch 3, tr in each of next 3 tr**, ch 7, sk next 2 ch-8 sps, tr in each of next 3 tr; rep from * across, ending last rep at **, turn.

Rep Rows 1–16 for pattern.

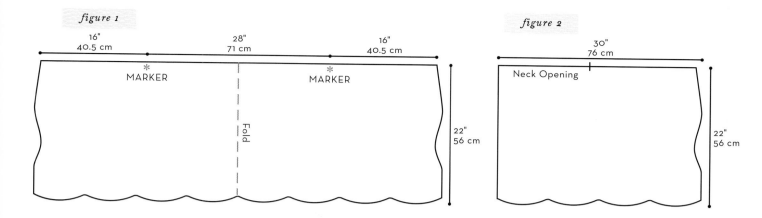

figure 1

16"
40.5 cm

28"
71 cm

16"
40.5 cm

*
MARKER

*
MARKER

Fold

22"
56 cm

figure 2

30"
76 cm

Neck Opening

22"
56 cm

instructions

Ch 175 (to make wider/narrower poncho, add/remove multiple of 18 ch sts).

Work body stitch pattern (see Stitch Guide) Set-up Row 1 and Set-up Row 2, then work Rows 1–16, then rep Rows 1–6.

ROW 23: Ch 1, sc in first tr, sc in each of next 2 tr, *6 sc in next ch-7 sp, sk next sc, 5 sc in next ch-6 sp, sk next sc, 6 sc in next ch-7 sp**, sc in each of next 5 tr; rep from * across, ending last rep at **, tr in each of last 3 tr, turn. Fasten off.

FINISHING

Block crocheted fabric to measurements (**figure 1**). Place markers 16" (40.5 cm) from each end on foundation ch. Fold in half lengthwise, and sew together between the end and the markers (**figure 2**). The remaining space is the neck opening.

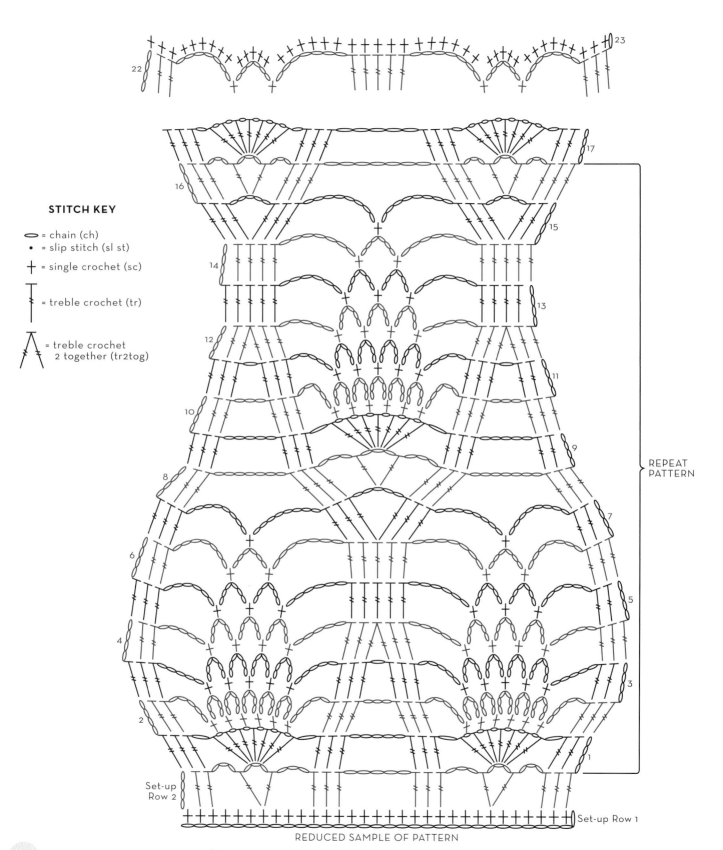

STITCH KEY

◯ = chain (ch)
• = slip stitch (sl st)
+ = single crochet (sc)
⌶ = treble crochet (tr)
⋀ = treble crochet 2 together (tr2tog)

REPEAT PATTERN

Set-up Row 2

Set-up Row 1

REDUCED SAMPLE OF PATTERN

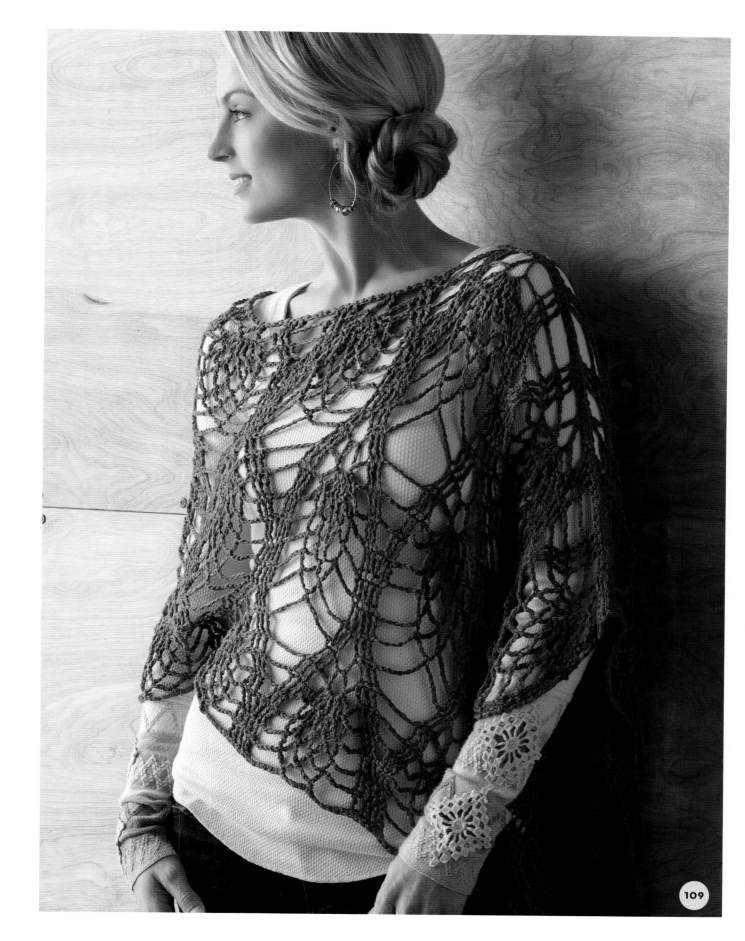

symbol key

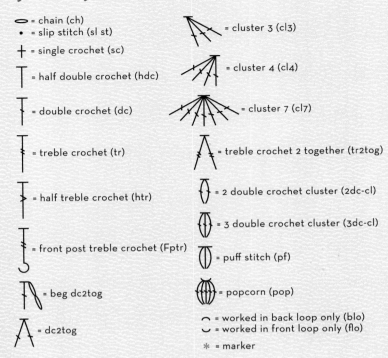

◯ = chain (ch)
• = slip stitch (sl st)
┼ = single crochet (sc)
┬ = half double crochet (hdc)
┬ = double crochet (dc)
┬ = treble crochet (tr)
┬ = half treble crochet (htr)
┬ = front post treble crochet (Fptr)
⟋ = beg dc2tog
Λ = dc2tog

⋏ = cluster 3 (cl3)
⋏ = cluster 4 (cl4)
⋏ = cluster 7 (cl7)
Λ = treble crochet 2 together (tr2tog)
⬭ = 2 double crochet cluster (2dc-cl)
⬭ = 3 double crochet cluster (3dc-cl)
⬭ = puff stitch (pf)
⊕ = popcorn (pop)
⌢ = worked in back loop only (blo)
⌣ = worked in front loop only (flo)
✳ = marker

sources for yarn

cascade yarns
PO Box 58158
Seattle, WA 98138
cascadeyarns.com

james c. brett
30/34 Clyde Street
Bingley, West Yorkshire
England BD16 2NT
jamescbrett.co.uk

rowan yarns
Green Lane Mill
Holmfirth, West Yorkshire
England HD9 2DX
knitrowan.com
Distributed in the U.S. by
Westminster Fibers
165 Ledge St.
Nashua, NH 03060
(800) 445-9276
westminsterfibers.com

skacel yarns
(800) 255-1278
skacelknitting.com

schoppel wolle
(800) 255-1278
skacelknitting.com

schulana
(800) 255-1278
skacelknitting.com

universal yarn
5991 Caldwell Business
Park Dr.
Harrisburg, NC 28075
(704) 789-Yarn (9276)
(877) Uni-Yarn (864-9276)

abbreviations

beg	begin(s); beginning
bet	between
ch(s)	chain(s)
cl(s)	cluster(s)
cm	centimeter(s)
cont	continue(s); continuing
dc	double crochet
dec	decrease(s); decreasing; decreased
dtr	double treble (triple)
est	established
foll	follow(s); following
g	gram(s)
hdc	half double crochet
inc	increase(s); increasing; increased
lp(s)	loop(s)
m	marker
MC	main color
mm	millimeter(s)
p	picot
patt	pattern(s)
pm	place marker
rem	remain(s); remaining
rep	repeat; repeating
rev sc	reverse single crochet
rnd(s)	round(s)
RS	right side
sc	single crochet
sk	skip
sl	slip
sl st	slip(ped) stitch
sp(s)	space(s)
st(s)	stitch(es)
tch	turning chain
tog	together
tr	treble crochet
tr tr	triple treble crochet
TSS	Tunisian simple stitch
WS	wrong side
yd	yard(s)
yo	yarn over
*	repeat starting point
()	alternate measurements and/or instructions

Index